Praise for *The Lost Art of Handwriting*

"Brenna captures the art of handwriting in such a beautiful way, from explaining the history and breaking down the basics to discussing her signature style of flourishing in this book. I was blown away by the information and topics covered in the book allowing me to see handwriting in another perspective. Such an amazing book that answers the 'why' and getting started."

—SHELLY KIM of *Letters By Shells*, author of *Learn to Create Modern Calligraphy Lettering* and *Learn to Create Art Deco Lettering*, each by Quarto Publishing

"I am absolutely blown away by the vast amount of information there is in this book, and at how wonderfully detailed it is. From diving into the history of handwriting to being able to successfully learn by practicing different types of styles with clear and beautiful examples, there is no doubt this book will help anyone improve—and thoroughly enjoy—their handwriting."

—CHRYSTAL ELIZABETH, modern letterer and author of *Brush Lettering Made Simple*

"A wonderful resource for anyone who is interested in penmanship! Brenna not only brings you into the rich history behind handwriting; she guides you through beautiful scripts and styles that will inspire you to put pen to paper."

—YOUNGHAE CHUNG of Logos Calligraphy + Design

"Brenna is a master of her craft and she doesn't hold back in these abundant pages full of instruction and inspiration. She has an effortless way of guiding you to fall in love with your unique handwriting—how to embrace it, mold it, and really own it—showing you the priceless value it has. This book is experimental yet timeless!"

—PEGGY DEAN, author and art educator

THE
LOST ART
OF
Handwriting

rediscover the beauty and power of penmanship

BRENNA JORDAN

Adams Media

New York London Toronto Sydney New Delhi

This book is dedicated to Brent Jordan.
Thank you for the year of handwritten letters that
changed the course of my life.
And for every year since.

Adams Media
An Imprint of Simon & Schuster, Inc.
100 Technology Center Drive
Stoughton, MA 02072

Copyright © 2019 by Simon & Schuster, Inc.

First Adams Media hardcover edition March 2019

ADAMS MEDIA and colophon are trademarks of Simon & Schuster.

For information about special discounts for bulk purchases, please contact Simon & Schuster Special Sales at 1-866-506-1949 or business@simonandschuster.com.

The Simon & Schuster Speakers Bureau can bring authors to your live event. For more information or to book an event contact the Simon & Schuster Speakers Bureau at 1-866-248-3049 or visit our website at www.simonspeakers.com.

Interior design by Colleen Cunningham
Handwriting samples by Brenna Jordan
Grip illustrations in Chapter 2 by Kathy Konkle

Manufactured in the United States of America

10 2022

Library of Congress Cataloging-in-Publication Data has been applied for.

ISBN 978-1-5072-0936-3
ISBN 978-1-5072-0937-0 (ebook)

Contents

Dancing
in all its forms
cannot be excluded
from the curriculum
of all noble education;
dancing with the feet,
with ideas, with words,
and, need I add
that one must also be
able to dance
with the pen?

FRIEDRICH NIETZSCHE

Introduction

Handwriting is a beautiful art form that connects us to one another. No two people share the exact style of handwriting, so your handwriting is an irreplaceable extension of yourself, providing a window into your unique personality. That's why handwriting is so important, even in our age of touchscreens and texting.

At this moment in history, we are fortunate to have both technology and the art of handwriting, with its many and varied implements, at our fingertips. We can appreciate the efficiencies and convenience that technological progress has brought us while still celebrating the fine art of penmanship. Besides, handwriting is not just a nostalgic nod to the past; it's a joy-inspiring and useful tool for our future—it can help us connect as humans even as we use computers more and more often.

The value of handwriting in relation to our interactions with others is immense. Handwriting is a slowing down, a connection with ourselves, one another, and the history of our complex humanity. And because there is an inexhaustible craving within us for beauty and creative expression, handwriting is getting noticed in our fast-paced culture.

Handwriting is designed for both functionality *and* enjoyment, in the same way we cherish a stroll along the beach or an artfully cooked meal savored among friends. (We could walk on a treadmill in a windowless gym or eat fast food alone in the car, but that's much less enjoyable, isn't it?) As a calligrapher and hand-lettering artist, I have the privilege of witnessing the profound reactions of people when they see their wedding vows, a favorite poem, or other meaningful words scripted by hand. I hear stories of what those words mean to them in the context of their lives and how special it is to see them handwritten with care.

Maybe you've picked up this book because you've noticed the renewed interest in handwriting for home

decor, business logos, and greeting cards. Perhaps you recall an era before email, when a cherished pen pal or loved one sent letters in their unmistakable penmanship. Or maybe you want an opportunity to relearn or improve upon the cursive you studied as a child, and need guidance to focus your practice time and form new habits. Whatever your reason for holding this book in your hands, you are certain to meet delight as you embark on your own personal journey with the limitless potential of the alphabet.

In this book, we will explore proper stroke technique, letter forms, and ideas for evaluating and improving your handwriting. You will discover how the astonishing variety of letter forms provide endless avenues for exploration and opportunities for making these alphabets your own, and how to choose alternatives that fit your preferences while retaining legibility and consistency. You will learn how to join letters in cursive writing to help you write more smoothly and, with practice, more efficiently. And we will discuss how to apply what you've learned to your everyday life, including tips for integrating handwriting into already jam-packed schedules.

You'll find blank lines throughout the book for practicing certain techniques. Photocopy the blank lined pages at the end of the book to use as extra practice pages.

In time, you will acquire a new love and appreciation for this gorgeous art form, which is available to anyone who puts pen or pencil to paper.

Acknowledgments

I'm grateful for the calligraphy and hand-lettering teachers I've studied with—each of you have unique passion and expertise: Amanda Arneill, Gemma Black, Pat Blair, Timothy Botts, Brenda Broadbent, Karen Brooks, Barbara Calzolari, Skyler Chubak, Harvest Crittenden, Suzanne Cunningham, Anne-Davnes Elser, Marion Gault, Eliza Holliday, Bill Kemp, Stefan Kunz, Kathy Milici, Vivian Mungall, Cora Pearl, Linda Schneider, Michael Sull, Michael Ward, Julian Waters, Jake Weidmann, Angela Welch, and Xandra Zamora. Special thanks to Sheila Waters and Julian Waters for reviewing the section in this book on the history of handwriting. I'm also thankful for the students I've been privileged to teach. I learn so much from you.

To the Colleagues of Calligraphy (Minnesota Guild) and IAMPETH (International Association of Master Penmen, Engrossers, and Teachers of Handwriting) and their members: thank you for your generosity, excellence, and ongoing effort to promote writing by hand and all of its benefits.

Many thanks to Beverly Patronas and Dr. Ladona Tornabene; I'm deeply grateful for your wisdom and encouragement. Thanks also to Curt Walczak and the staff at the University of Minnesota Duluth Center for Economic Development.

Thank you to my editor Cate Coulacos Prato, the first to envision and believe in this project, Colleen Cunningham, Laura Daly, and the staff at Adams Media and Simon & Schuster for your incredible work and talent.

As Robert Louis Stevenson observed, "We are all travelers in the wilderness of this world, and the best we can find in our travels is an honest friend." I'm thankful to travel through life with these loyal friends: Brenda DeJaeghere, Rhonda Gazette, Michelle Gunnerson, Amy Hellerstedt, Julie Jonson, Jennifer Kampf, Deb Kester, Son Nguyen, Tami Perez, Brenda Swanson, and Esther Young.

Thank you to my extended family, a tremendous source of support and inspiration: siblings Sam and Lydia Foltz, Sair and Nick Jordan, Angela and Aleks Tengesdal, Walter Foltz, Sharla and Lance Green, cousins Elizabeth Schulte, Bonnie Fahoome and Rob Foltz, aunts Bonnie Foltz and Julia Todink, and especially my mom, Lois Gelia Foltz, as well as many relatives too numerous to list. I'm also grateful for treasured memories with my dad, Frank Foltz, and grandparents, Louise and Rugg Foltz and Ethel and Walter Lundin, who instilled in me a love for books, handcrafts, and great quotes.

I'm so lucky to live with my favorite people, who did all the grocery shopping and much more, so I could finish this book on time. Brent, thank you for believing in me with an unwavering love and kindness, cheering me on throughout every page of this book, and knowing how to make me laugh no matter what kind of day I'm having. Jace, Jayva, and Jenaya: I'm so proud of you and how you search for ways to make this world a better place. And finally, a million thanks to God, the Giver of good gifts: All my springs of joy are in You. —Psalms 87:7.

The Case for Handwriting in a Digital World

We Have Room for Both

Handwriting and type evoke different responses in the person reading the words. Each one is good for certain circumstances and each one can serve a different communication purpose, so type doesn't need to completely replace handwriting. Sometimes type is the best form of communication—for presenting a work project, submitting school term papers, or sending a group of people some logistical information, for example. But let's learn about the many benefits that the handwritten word offers.

Handwriting Gives Insight Into Your Personality

Like hearing someone's voice, associating someone's handwriting with him or her offers a powerful connection and deepens the friendship or relationship. There are so many variables in our writing styles—the roundness or sharpness of our letter shapes, the slant of our writing, the pressure we use, the size and spacing of our words, and so on.

Writing by hand has a creative and artistic appeal that typing can't provide in quite the same way. When we form a letter, we decide how to cross that *t* and exit the last stroke of a letter. These choices lead to our distinct handwriting style, and help others recognize it—and us—in turn. Have you ever noticed how seeing someone's handwriting reminds you of their personality? Their script may be tidy and precise, or large, loopy, and energetic. Handwriting can reveal clues about the writer's inner characteristics.

Handwriting Connects Us to the Past

Competency in cursive writing has the additional advantage of helping us better understand our past. Without an understanding of

✎ handwriting heroes

J.K. Rowling, author of the Harry Potter series, is one of many writers who believes using handwriting rather than type facilitates better thinking. "Normally I do a first draft using pen and paper, and then do my first edit when I type it onto my computer....I have been known to write on all sorts of weird things when I didn't have a notepad with me. The names of the Hogwarts Houses were created on the back of an aeroplane sick bag. Yes, it was empty."

traditional penmanship, we are unable to read historical documents. Even though some of the letter forms have evolved over time, you can still decipher words that helped found nations, tell amazing stories, and track family histories.

Handwriting also enables people to sign their names, a basic and fundamental skill used in everyday transactions for centuries. In spite of technological advancements to replace the need for signatures, there's an emotional and assertive dimension to a person's signature that handwriting helps retain. Whether you see your own handwriting on an old document or your grandparents' signature on an immunization card, you feel a deep connection to that person and that point in time.

Handwriting Inspires Creativity

Besides the functional aesthetics of handwriting, neurologists have discovered that freewriting can improve neural connections in our brains and spark creativity. Freewriting on paper can relax you, allow your thoughts to flow freely without worrying about spelling or comprehension, and encourage you to think outside of the neat lines of word-processing software.

Handwriting can also create or complement so many different handmade crafts. Hand-lettered mugs, tote bags, and prints are popular ways to express yourself—and decorate your space.

Handwriting Can Help You Remember Things

When adults are learning new symbols that are not part of their current knowledge, such as Chinese characters, musical symbols, or chemistry formulas, the benefits of writing them down by hand are greater than other techniques of mastery and memorization.

A series of experiments published in *Scientific American* showed that while students on laptops were able to type faster and accumulate more notes than students who scribed by hand, they did not process or remember the information as well as those who put their pens to paper.

Students who wrote on paper were forced to prioritize the importance of the lecture material, since they didn't have time to write everything down. In the long run, this process helped them achieve a better grasp on what they had heard and encode it more firmly in their memories.

Even if you're out of school now, you can still handwrite whenever you want to remember important things, such as notable dates in your life, key information from a meeting, or inspirational quotes.

Handwriting Can Relieve Stress

Handwriting in a journal can offer a wealth of self-care benefits. James Pennebaker, a psychologist at the University of Texas, researched the effects of daily journaling by hand. He discovered that journaling, even just for a few minutes a day, built up T-lymphocytes, cells in the immune system, and reduced the symptoms of arthritis and asthma. Further research suggests that writing in a diary about life events also relieves stress and promotes emotional well-being.

Handwriting Evokes Emotions

There are times when a handwritten note delivers much more powerfully and personally than a typed note or form letter. A handwritten sympathy card or thank-you letter to a teacher or wedding guest expresses emotion and thoughtfulness and honors the recipient. These tender moments of life are enriched by taking a little extra time to slow down and use pen and paper.

●✧ practice tips

Keeping a journal is a great way to practice handwriting while simultaneously sorting out thoughts. The writer and poet Anne Morrow Lindbergh (1906–2001) kept diaries for decades and defended it as a worthwhile pursuit: "I must write it all out, at any cost. Writing is thinking. It is more than living, for it is being conscious of living."

Appreciating All Kinds of Writing

Handwriting is a gift to society, spanning all ages, cultures, and customs. The convenience of our keyboards is undeniable, but balancing type with the beauty and benefits of handwriting will bring pleasure into your life and the lives of those around you.

Getting Started

Cursive

Printing

Putting It All Together

Penmanship Basics

The History of Handwriting

Where did we get the twenty-six letters and variety of handwriting styles we use today? It's humbling to think about the distance writing has traveled across the centuries and the diverse needs of the many cultures it has served. Just as our lifestyles, traditions, and innovations are always changing, handwriting has been dramatically altered by progress and cultural shifts.

From the early beginnings of hieroglyphs, carved on stone by the Egyptians (3000 B.C.), handwriting evolved to the Phoenician writing system (1500 B.C.), which was comprised of twenty-two phonetic symbols. When the Roman Empire conquered Greece and rose to power, they borrowed from the Greeks to create a twenty-three-letter alphabet for carving into stone and writing on parchment scrolls.

The letters *U*, *W*, and *J* were added to the Roman alphabet in the tenth, twelfth, and fifteenth century, respectively, to bring the count up to the twenty-six letters we know today. In the sixteenth century, England was rapidly advancing in commercial trade and needed scribes for business writing and record keeping. Special schools to teach penmanship sprouted up in order to meet the growing demand for an efficient, legible form of writing. Because the heads of the schools were in sharp competition with each other in their efforts to attract students, they produced an abundance of copy books. These renowned penmen filled their pages with virtuous sayings and flowery advertisements trying to outdo other schools with their writing prowess.

> **•◗ fun facts**
>
> Egyptians and Sumerians were among the first to invent writing systems. The Egyptians used hieroglyphics, a form of picture writing, which they carved into stone, while the Sumerians designed a system of writing in clay called cuneiform. Unlike the twenty-six letters in the modern English alphabet, some one thousand characters were employed in these ancient writing systems.

A couple of centuries later, with literacy on the rise and public schools in session, there was a need for a more efficient system of teaching handwriting to the general population. Platt Rogers Spencer (1800–1864) made it his life's ambition to meet this need.

Considered the father of American penmanship, Spencer was obsessed with handwriting. Even as a young child, he practiced his penmanship on scraps of leather and birch bark, and used a stick to write letters in sand or snow. Over years of meticulous practice, he developed the Spencerian hand that became known for both its elegance and its practicality. The ovals and gentle swooping lines that are prolific in Spencerian writing were drawn from Spencer's observation of rounded stones and waves. By 1850, Spencerian was the standard writing system taught in American schools.

▼ An example of Spencerian capitals.

By the late 1800s, however, Spencerian was losing traction because Austin Norman Palmer (1860–1927) developed an alphabet that was faster and more practical and allowed the hand to write for longer periods without getting tired. To promote his method, he published the award-winning *Palmer's Guide to Business Writing*, which went on to sell one million copies. Schools soon picked up the methodology, and the Palmer hand was taught from the late nineteenth to the mid-twentieth century.

By the 1950s, the Palmer method had fallen by the wayside in American schools. Educators now favored children learning how to print before learning cursive, and other styles such as the Zaner-Bloser method stepped in to meet the new demand. Still used in schools to this day, this system teaches a standard vertical printing style and a slanted cursive.

Teaching handwriting in schools has been rapidly declining in the twenty-first century, as computers, cell phones, and other technology take precedence in students' daily lives. Forty-one of the fifty states have adopted the Common

●◆ fun facts

In the 1700s, books were reproduced by a method called copperplate engraving. An engraver worked with a sharp wedge-shaped tool called a burin, to etch the letters and designs onto a metal plate. The reversed design was slathered with a thick ink, which was rubbed into the etched lines. Then the plate was wiped down thoroughly and rolled through a press onto paper. The detailed process produced Roundhand letters, distinguished by the elegant contrast of delicate hairlines with heavy downstrokes.

Core Curriculum Standards, which leave cursive out of the required subject matter. Lawmakers, educators, parents, and other citizens continue to debate the merits of spending time on handwriting instruction in our high-tech world. Proponents of handwriting argue that technology can't replace the benefits of cursive, and cite research done by psychologists and neuroscientists to support their claims. Since the Common Core Standards were launched in 2009, over a dozen states have passed laws mandating cursive instruction in the classroom, affirming the value in students learning to sign their names and read historical documents.

Handwriting has always provided important clues to culture and society norms. We can look between the lines to discover where we have been and what we value. Those who have discovered the love and beauty of creating letters by hand will continue spreading the word, while the changing climate of handwriting continues its unpredictable course through history.

●◆ **fun facts**

We're happy with once-a-day postal delivery, but in the days when snail mail was at its peak, some locations received over half a dozen mail deliveries a day! In 1922, the top business districts in Brooklyn and Philadelphia kept postal workers running to provide seven deliveries a day. In 1950, mail delivery was reduced to one trip a day in residential areas, but businesses continued to receive extra deliveries for a few more years.

Helpful Terms

Before you get started, I'd like to introduce you to a few basic terms we'll be referring to throughout the book.

Guidelines are simply lines to help you write straight and keep your letters within a designated framework. The ones we will be using in the book are a little more detailed than basic notebook paper—they have additional lines showing where the tops and bottoms of your letters should land. You can use guidelines that are directly on your writing sheet, or place them behind a blank sheet that is transparent enough to see the lines through. Some guideline templates also include slant lines that cross through the horizontal lines at regular intervals to enable writers to slant all their letters to the same degree.

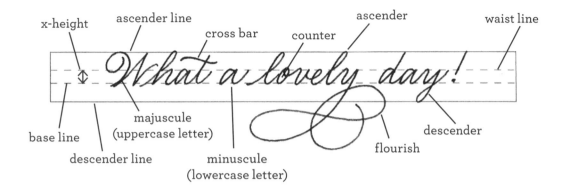

A **majuscule** is an uppercase or capital letter and a **minuscule** is a lower-case letter.

The **base line** is an important guideline for both uppercase and lower-case letters, as the letters will (in most cases) sit directly on this line. This will make your writing easier to read and also give it a neater appearance.

The **x-height** is the height of the lowercase x, a, c, e, m, n, and other letters that do not have ascenders or descenders.

An **ascender** is the portion of the lowercase letter that extends beyond the waist line, while a **descender** is the part of the letter that drops below the base line.

The **waist line** provides a boundary for the top of the x-height letters and a reference point for letters containing ascenders and descenders. For example, in the letters d and g, the rounded part of the letter will stop at the waist line, while the stem continues up or down.

The **ascender line** marks the spot where the tall stem in letters such as b, d, f, k, and l will touch. If the ascenders are too short, they can easily be confused with other letters. The **descender line** marks the bottom of the letters g, j, p, q, y, and the cursive f.

A **counter** is the enclosed space within a letter, such as in an *o*, *a*, or *d*.

Ductus, the Latin word for "leading," shows the sequence and direction of the strokes that make up a letter.

Flourishing is the extra embellishment that you can incorporate into your handwriting, often at the end of ascenders, descenders, and downstrokes, or on the **cross bars** (horizontal strokes) of letters such as *A*, *H*, *t*, and *f*.

The Write Tools

The tools required for handwriting are simple items you most likely already have: pencils, pens, paper, and a few optional accessories. There are so many types of writing utensils, however, and the one you choose can make a huge difference in your enjoyment of practicing. Take your time experimenting—it's worth the investment to find a high-quality pen or pencil that fits comfortably in your hand and that you enjoy using.

☙ practice tips

As your handwriting practice gains momentum, you might be surprised by how you will notice the hand lettering and typography around you with new interest. Carry a small notebook to jot down inspiration and ideas when they strike. Taking pictures of letters is one method of gathering ideas—for example, in signage or other typography that catches your eye. But I have found that it's even more helpful to take my own pencil to paper as often as possible to try improvising an alphabet for a fascinating letter I come across. I also have an alphabetical index file where I store the letters that I've written and don't want to forget. This way, when my ideas are at a low, I can turn to my collection for inspiration.

Pencils

If you prefer using a pencil, they work great for practicing. It can be confusing figuring out the grading system on pencils, so here's a brief overview. There are two grading scales referring to the graphite in pencils:

1. The first is numerical, with the number representing the hardness of the core. A lower number means that the core is softer and will produce darker lines.

2. The second grading system uses letters: *H* for hardness, *B* for blackness. *HB* is considered equivalent to an average Number 2 pencil, but different brands have their own regulations. A high number after the *H* means a harder core, while a high number following a *B* means a softer core.

Although they are blacker, the disadvantage to soft pencils is that they need to be sharpened more frequently. Hard pencils hold their point longer and will leave lighter, sharper lines. You may want to experiment with several brands and grades to find out what you like best. There are many more, but a few recommended pencils are Blackwing, Staedtler Norica, and Staedtler mechanical pencil.

Pens

You will also want to experiment to find a pen that you enjoy using when you practice handwriting. Make sure the pen feels comfortable in your hand and writes smoothly, without scratching, blotching, or smudging. If you use a lot of pressure when you write, keep that in mind when selecting a pen to write with. Try a variety of types, and find what helps you lessen the pressure exerted through your fingers, hand, and wrist. After writing with a few different pens, take a look at the results. When you find a pen that makes your writing look fantastic, you will be more likely to keep up with your practice.

For pens, try Uni-ball Vision or Signo, the Pentel EnerGel, or you can experiment with Microns, Faber-Castell, and Paper Mate Liquid Expresso pens. If you don't already own a fountain pen, try one as soon as you can! The right tool can be magical, and a good fountain pen takes handwriting to a whole new level. A Lamy Safari fountain pen, with a refillable ink reservoir, is one I recommend. It's easy to refill and has nifty built-in contours for finger placement that make it comfortable to hold (try out several different brands in a pen store, if possible, before

●◆ handwriting heroes

George Clooney, famous actor, director, and writer, revealed that he uses pen and paper for all his projects. "I'm probably the least computer literate writer there is....Literally when I cut and paste, I cut pages and tape them together."

you decide which one to buy). Besides being really fun to write with, it enables me to write for long periods of time. The Pelikan Classic M205 is another fountain pen brand you might want to check out, as well as the Scribe Sword, the Faber-Castell Ambition, and the Kaweco Classic Sport Guilloch 1930. The Platinum Preppy is a disposable fountain pen that is easy on the budget, while many fountain pens use easy-to-replace cartridges, if you prefer that style.

Paper

It's best to use lined paper for most of your practice, with detailed guidelines in place if you like the extra lines for keeping ascenders and descenders at a uniform height. I use an assortment of notebook or loose-leaf paper, Rhodia pads (lined or dotted), graph paper, and Moleskine or other lined journals. If you prefer unlined paper, use a weight that is transparent enough for you to put a sheet of guidelines behind. And remember to save a compilation of these prac-tice sheets, so you will be able to look back and see your progress. You will be amazed at how much you can improve in a short time.

● fun facts

The first ballpoint pens in the US hit the market in 1945 as an alternative to fountain pens, which use nibs and cartridges for filling the ink. The public enthusiastically embraced the new pens when they were introduced, and quickly converted to the ball bearing point, which dispensed the ink and didn't need refilling as often as a fountain pen. Later, disposable ballpoint pens replaced the refillable versions.

Optional Tools

A **slant board** allows you to work on a sloped surface if you prefer that over writing flat. Some people are also greatly helped by a **pencil grip** made with flexible plastic or rubber, which slips on your writing utensil and makes it easier to keep a good hold if the pencil feels too narrow or slippery. If you find that your hand cramps easily or gets sweaty when writing, a pencil grip may be more comfortable and enable you to write for a longer time.

Pen Grasps

It's surprising how many varied and creative ways exist for holding a pen, but we'll cover the most common holds and discuss when to change a pen hold.

A. Dynamic Tripod Grasp This is the most common and recommended pen hold. The pen is held between three fingers: the index finger, thumb, and middle finger. The ring finger and pinky curl inward toward the palm and support the hand. With the fingers able to move freely, this grasp is an effective one for producing accurate writing. The pen is held at an angle, but the point of the writing utensil is in contact with the paper. Because it is easy to learn, the dynamic tripod grasp is the pen hold most often taught in schools.

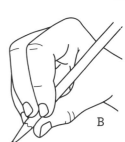

B. Dynamic Quadrupod Grasp This pen grasp is similar to the tripod, except four fingers are in contact with the pen, rather than three: the thumb, index, middle, and ring fingers. Only the pinky supports the hand.

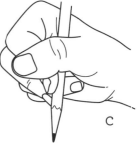

C. Lateral Tripod Grasp This pen hold is similar to the dynamic tripod, except the open space in the cup of the hand is closed off by the thumb curling back over the index finger. The hand may become more cramped and tire more quickly when using a lateral grasp.

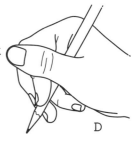

D. Lateral Quadrupod Grasp This pen hold involves the index, middle, and ring fingers, with only the ring finger supporting the hand, and the thumb wrapping over the pencil to rest on the index finger, similar to the lateral tripod grasp.

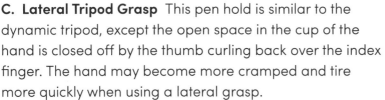

E. Adapted Tripod Grasp The pencil is placed between the index and middle finger of a cupped hand, held by the thumb and index finger tips and resting on the middle

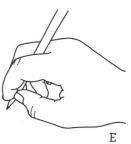

finger. The pencil is held more upright when writing. This pen hold may be unconventional, but does allow for both freedom of movement and stability. Occupational therapists sometimes recommend this grasp for their patients with tremors and arthritis, and it helps alleviate cramped hands, illegible writing, and discomfort. It's particularly helpful if your thumb tends to get sore when writing. This grip is also called the Modified or D'Nealian Pen Grasp.

Which Grasp Is Right for You?

All of the pen holds shown here are functional, and there is no need to change how you hold the pen if you are comfortable and satisfied with your results.

There are several inefficient grasps, however (such as holding the pen in your palm with fingers clenched around it), that can make it difficult to write for any length of time and to write at a normal speed. If you have stress on your joints, or any pain or stiffness, it may be caused by your pen hold. An improper pen hold can also contribute to fatigue or illegible handwriting. If you run into any of those issues, consider adapting your pen hold to one of the efficient grasps just described.

◆ practice tips

If you tend to clench your pen too tightly and your hand gets tired quickly, here's a trick to help train your hand to relax. Grip a pen or cap or some other object in your non-writing hand (a sharpened pencil works well, because you can grip it while pressing it into a piece of paper, but experiment to find what works for you). It's hard to maintain a tight grip with both hands, so your writing hand will naturally loosen up.

Posture

Having good posture when handwriting will prevent strain on your body and help your writing look its best. Make sure you are seated comfortably with your elbows at about a 90-degree angle and your feet flat on the floor. Ideally, you want to have a table or desk in front of you, so you can rest your hands on a hard surface. Relax your arms and shoulders, and avoid hunching over your work.

Some people have a hard time maintaining good posture when they are working on a flat table or desktop. If writing on a level surface is uncomfortable for you, try using a slant board. You can experiment with the angle that works best for you, but aim for less than a 45-degree slant.

No matter what style of surface you use, make sure your writing arm has enough space to move freely. Take a break to stretch (flex your hands, then roll your wrists, shoulders, and neck) every few minutes, or whenever you feel that tension or stiffness has been building. When writing, try to think about including your entire arm and wrist along with your fingers so both large and small muscle groups are working together.

Paper Position

Always aim to have your tools and paper work for you, not against you. When you are relaxed, you can then align your tools to fit your ideal posture. How you position your paper will help tremendously in writing more naturally and comfortably. (If you've ever had to write something while riding in a car, you'll know that ideal conditions are important for legibility as well!)

Position your paper at an angle that is comfortable for you—tilted to the right if you are left-handed, and to the left if you are right-handed, at a good balance so your elbow isn't sticking out too far or cramped too close to your body. Once you start writing, it's tempting to tweak your posture as you progress down the page. Instead, slide the paper to keep the line you are working on in the optimal zone for your hand and forearm.

Tips for the Left-Handed Writer

A tripod, or three-finger grip, works best for left-handedness. Hold your pen or pencil between your thumb and forefinger and rest it on your middle finger. Grip your pen at least two finger tips away from the tip of

your pen. Triangular-shaped pencils are a great resource to help maintain a tripod grasp. Both Faber-Castell and Staedtler carry triangular pencils that are especially helpful for left-handedness.

Tilt your page to the right and make sure you have sufficient space on your left to be able to move your arm comfortably. You may also find it easier to use loose-leaf paper rather than spiral-bound notebooks, or buy notepads that are top bound, such as Maruman Mnemosyne or Rhodia notebooks. Choose smooth paper to prevent the writing utensil catching on the page. (Handmade paper is an extreme example of paper that's not smooth, but even among "regular" paper, you can notice variations in smoothness. For example, a premium LaserJet paper will be smoother than regular copy paper.) You can also use quick-dry notebooks with more absorbent paper—a good choice is Doane Paper Grid + Lines Flap Jotter notepads. This is a great help if your left hand tends to smear your ink as you move across the page.

Choose a pen with fast-drying ink, which also helps guard against smudging. The Uni-ball Jetstream ballpoint pen is good for left-handers, with specially formulated ink that dispenses smoothly with little pressure and dries super quickly. Also, because you are pushing the ink across the page, rather than pulling it like someone who is right-handed, it's crucial to have a pen with smooth-flowing ink. Experiment with rollerball ink pens, non-smudge felt-tip pens, or fountain pens that are specially designed for left-handers. If you have trouble with your hand blocking your letters, you can also find pens that have angled tips, which allow you to maintain a comfortable grip as well as view what you are writing without hooking your arm around your writing.

●◆ fun facts

In the eighteenth and nineteenth centuries, librarians were required to use a special handwriting style that was designed specifically for writing catalog card entries. Melvil Dewey, inventor of the Dewey Decimal System, helped to establish the Library Hand. Dewey and his comrades frowned on librarians using any personal flair or flourishing in their penmanship, demanding that they scrupulously adhere to their rules for writing.

Mastering the Art

of Handwriting

The Dance of Writing

How would you describe your handwriting? You may think you write too small or too slanted, or wish you could write straighter on a blank piece of paper. For most of us, it's easier to pinpoint flaws than give ourselves credit for good qualities. But the amazing thing about handwriting is that it's uniquely *yours*, a tangible expression of your personality in a way that type is not. As we practice, we'll be celebrating the creative process of writing by hand each step of the way. It may seem ordinary and even unnecessary with today's technology, but when we really think about it, handwriting is as magical and exquisite as a dancer moving across the stage.

I often think of handwriting as a dance across the page. We'll find many parallels as we explore the art of handwriting. Dancers need to warm up; they require daily practice and strategic focus on challenging techniques. Over time, movements that once were difficult become effortless. When a step is mastered, there's always something new to learn. But where to start?

Sometimes our handwriting can be hard to read. What exactly makes handwriting legible? Most of the exercises in this book help to sum up the answer in one word: consistency. There are five areas of consistency we will be taking a look at: consistency in size, slant, spacing, style, and pressure. As your eye becomes more trained, you will be able to spot inconsistencies in your handwriting, and target your practice time on those areas.

> **●◆ fun facts**
>
> Snail mail with illegible writing ends up in Salt Lake City, Utah, at a special branch of the US Postal Service. Over 1,200 employees work 24/7 to decipher over four million pieces of mail a day. The number of illegible envelopes and packages skyrockets in December with the high volume of holiday mail.

Size

First, let's consider consistency in size. When you look at a sample of your handwriting, do you see any letters that stand out because they are

larger or smaller than the others? Are the words on the top line approximately the same size as the words on the bottom of the page? Inconsistencies in size will interrupt the flow and can even affect legibility. For example, a cursive *L* can easily look like a cursive *E* if the loop sizes don't maintain a consistent height, and words with these letters will be harder for the reader to decipher.

The quote on page 34 by Teresa R. Funke is a perfect fit for practicing consistency. It contains an abundance of loops: eleven *e*'s, seven descenders, and more than twenty ascenders. Making a conscious effort to be consistent with the height and width of similar letters can take some getting used to. Once you get in the habit, you will improve legibility and also achieve more fluid and precise handwriting. Using paper with guidelines is extremely helpful to keep your letters within boundaries; it also helps you keep an eye out for uniformity in the size of your counters and ascender and descender loops.

⊷ fun facts

In 1748, Benjamin Franklin (borrowing many details from George Fisher's *Young Man's Best Companion*) published models of impeccable handwriting in *The American Instructor*. John Jenkins's book *The Art of Writing*, published in 1791, also broadened the scope of copperplate engraving in America. Both the Declaration of Independence and the US Constitution were printed from plates that scribes of the day had etched using the script style that became known as Copperplate.

Slant

Another area of consistency is the slant of your letters. Look at a piece of your handwriting. Does your angle stay consistent? This isn't as crucial to legibility as consistent size is, but it will make a big difference in the cohesive appearance of your writing. Let's take a word like *fulfillment*, with a lot of ascenders. These ascenders look cleaner and more appealing when they are parallel.

If you're not sure about your slant consistency, here's a great way to check: take a sample of your handwriting that has a few lines of text, or create one with any of the quotes provided in this book. Using a ruler, extend the straight vertical lines (for example, the downstrokes that

appear in the letters *f* or *l*) a few inches above and below with a pencil. When you're done, you'll want to see pencil lines that are fairly parallel, not crisscrossing in several directions.

Spacing

The next tenet of legible writing is an especially important one: spacing. This takes extra mindfulness, since good spacing is necessary in four places: within the letter itself, between letters, between words, and between lines. It's not quite as important how much space you decide to leave, as long as the spaces stay consistent and the words can be read efficiently.

If you need help critiquing your spacing, try this tip: take a page of your handwriting and turn it upside down. When you're not distracted by the meaning of the words, you can see them more as shapes and observe the balance of white space as an artistic exercise.

Style

Consistency in style is another area to keep in mind. We all develop our own style of writing, with nuances that express our personal preferences. The goal for your handwritten page is not to be consistent with someone else's style, but with your own. If you begin writing with smooth and loopy letters, try to keep the same letter forms going, instead of switching midway to, say, a sharper, angular style. It's handy to utilize lots of different styles for different projects, as long as they aren't competing with each other in the same piece of work.

●◆ handwriting heroes

You never know when handwriting will be a literal lifesaver. John F. Kennedy and his crewmates were stranded on an uninhabited island in the Pacific during World War II. He carved a message into a coconut shell requesting a rescue from the Allied troops and sent it with two Solomon Islanders who were paddling by. The coconut husk was later returned and made into a paperweight that he kept on his desk in the Oval Office when he became president.

Pressure

Finally, think about the amount of pressure you use when writing. Many of us are more heavy-handed and have to make an effort to use a lighter touch. When you find what works well for you, try to maintain a steady, even pressure. This will prevent any noticeable variations in the weight of the letters. Also, consider the amount of pressure you use when you are selecting writing tools. The right combination of paper and writing utensils can make a huge difference in producing good results.

Speed

As you practice writing, take note of your speed. In fact, a key to mastering consistency and neatness more quickly may be an ironic one: slowing down. Writing more slowly, especially when you are learning or changing deeply rooted habits, will give you time to recall good technique and build muscle memory. Practicing slowly will help with accuracy and control, as well as with the areas of consistency we've just covered.

Margins

Margins provide necessary white space to make your piece of writing look cleaner, and give it room to breathe. Paper that is marked with margins helps to prevent crowding your piece with words that run too close to the edges. It's a good idea to allot generous margins, in case of the few letters here or there that must run over the right margin a little to finish the word. Start by observing margins when you look at text, other

●◆ fun facts

While we are accustomed to beginning our sentences on the left side of a page and moving right, some scribes orient their text differently. Hebrew, Arabic, and Persian are a few of the world's languages that are written from right to left. Traditional Chinese, Japanese, and Korean writing has another notable difference: characters are written vertically, from top to bottom, while also starting on the right side of the page and moving left.

people's handwriting, and your own. When we are convinced of the appeal of margins, it's easier to incorporate them into our own writing.

Putting It All Together

Being mindful of all these areas of consistency while you're writing is a juggling act, but don't get overwhelmed thinking of everything all at once. Look at your handwriting objectively and select one area that you'd like to work on first. Ignore any other habits for the time being, and just work on that area until you see improvement. But don't stop there—keep practicing until you can achieve the results you want effortlessly.

Building your confidence is motivating, and it will propel you to surmount the next hurdle. Maintain your practice with the fun ideas discussed later in the book, and remember to celebrate your progress along the way.

● fun facts

The iconic Coca-Cola logo is a famous example of Spencerian script, which was the typical style of handwriting taught in America from about 1850 to 1925. The logo was designed in 1885 by Frank Robinson, the founder's partner and bookkeeper, who was especially in favor of the name having two capital *C*'s. Today it is one of the most recognized logos in the world.

True ease in writing
comes from art,
not chance,
As those move easiest
who have learn'd
To dance.

ALEXANDER POPE

‿ℓℓℓ‿ **TRY IT:** Copy the quote on the blank lines.

It's ever so fun and fulfilling to be clever, but more lasting and effective to be consistent.

eell **TRY IT:** Copy the quote in order to practice size consistency.

SPACING PRACTICE

minimum *minimum*

Nothing great was ever
achieved without enthusiasm.

TRY IT: Practice writing the word *minimum*, a common word used to check your spacing. Aim to keep the space within the letters, like the hills of the *m*'s and *n*'s, equal to the space between the letters. Then try writing the quote on a piece of practice paper for extra practice.

SLANT PRACTICE

fulfillment *fulfillment*

The most tempestuous
wind cannot disturb
the quiet of the stars.

TRY IT: Write the word *fulfillment* to practice slant consistency. Then try writing the quote on a piece of practice paper for extra practice.

A good week,
a week of peace,
may gladness reign
and joy increase!

"SHAVUA TOV"

TRY IT: Write the quote and concentrate specifically on keeping whatever style you start with consistent throughout your piece.

Each time we face our fear, we gain strength, courage, and confidence in the doing.

THEODORE ROOSEVELT

eell **TRY IT:** Write the quote and concentrate specifically on writing slowly to practice accuracy and control.

Then come the
wild weather,
Come sleet or
come snow,
We will stand
by each other,
However it blow.

HENRY WADSWORTH LONGFELLOW

_ꝯꝯꝯ **TRY IT:** Observe the margins as you write this quote.

Lowercase Letters

Lowercase Warm-Ups

Handwriting exercises may not seem very exciting, but they're a shortcut to developing smooth writing. You'll improve your consistency in size and spacing, and learn good technique regarding the shape and direction of strokes. Get in the habit of doing warm-up exercises each time you practice. Slow and methodical practice will prepare you to write faster, yet still legibly, when you need to get something down on paper quickly. But for now, take your time; it will definitely pay off!

- **Parallel lines (line 1):** Make sure the strokes start at the ascender line and touch the base line, and keep them straight, parallel, and equally spaced. Practice them in a downward direction, then reverse it and make a row of parallel lines using upstrokes. Do you find one harder than the other?
- **Underhand and overhand curves (lines 2 and 3):** Try to keep these strokes consistently sloped and uniform in height.
- **Hills, valleys, and curves (lines 4–7):** Work on maintaining uniform shapes. Evaluate the white space, as well as the lines, when you are finished with a line of exercises.
- **Ovals (line 8):** This important exercise will help you with the rounded shapes found in both the lowercase and uppercase letters. Check your ovals for consistent slant, shape, height, and symmetry.
- **Loops (lines 9 and 10):** Practicing loops will help you with the ascender and descender letters. Work on forming even loops with smooth, rounded tops, and keeping all the counters (enclosed white spaces) as consistent as possible.
- **The *j* shape (line 11):** The *j* shape exercise gives you a chance to work on your descender loop. Check to see if you can achieve rounded loops, even counters, and smooth transitions from the descender line up to the waist line.
- **The eyelid shape (line 12):** This exercise is the exit stroke of the *b*, *o*, *v*, and *w*. Practicing this stroke as an isolated form will help when it comes time to putting strokes together to form the letter, and also when you practice joining cursive letters later on in the book.

LOWERCASE WARM-UPS

1.
2.
3.
4.
5.
6.
7.
8.
9.
10.
11.
12.

eee **TRY IT:** Trace over the gray letters to practice.

Spacing Exercise

This exercise is really effective for building consistent letter forms. Write the line of *nu*, giving special attention to consistent spacing within and between the letters. To double-check, turn the page upside down and see if all the white spaces between letter strokes are fairly uniform in size.

nu LETTER COMBINATION

nununununununu

nununununanana

ꝓꝓ **TRY IT:** Trace over the gray letters to practice.

Exercise with *hy*

A great way to check for consistency is to turn your line of joined *h*'s and *y*'s upside down. Do they look the same? If it's a challenge getting the ascenders and descenders to look uniform, try slowing way down. It's tempting to want to make loops quickly, like roller coasters. Try writing them in slow motion and observe the difference in your results.

hy LETTER COMBINATION

hyhyhyhyhy hyhyhyhy

ꝓꝓ **TRY IT:** Trace over the gray letters to practice.

Loopy Exercise

Make a line of short and tall loops. Lowercase *e*'s and *l*'s are often mistaken for each other, because their only difference is height. This exercise will help you build fine motor control and aid in legibility when you need to write fast.

"el" LETTER COMBINATION

elelel elelel elelel

ell **TRY IT:** Trace over the gray letters to practice.

Lowercase Families

To help you learn and practice more effectively, the lowercase alphabet is divided into five family groups based on the similar features of the letters:

- The waves
- Rounded letters
- Loopy letters
- Odd cousins
- Loop variations

The following exercises will help you build muscle memory, as you'll be working consecutively on the same type of strokes found in that letter family.

THE WAVES

i i i i i i

t t t t t t

wine glasses m n u v w y

m m m m m m

n n n n n n

u u u u u u

v v v v v v

w w w w w w

y y y y y y

VARIATIONS

m m n n u u v v w w y y

TRY IT: Trace over the gray letters to practice. Create your own letter in the blank spaces provided after the gray letters. Then try the variations.

ROUNDED LETTERS

(handwriting practice rows: a c d g q o p a c d g)

a — practice row

c — practice row

d — practice row

g — practice row

q — practice row

o — practice row

p — practice row

VARIATIONS

o o o — practice row

p p p — practice row

TRY IT: Trace over the gray letters to practice. Create your own letter in the blank spaces provided after the gray letters. Then try the variations.

LOOPY LETTERS

e b h k l f j e b h k l

e

l

h

k

l

f

j

VARIATIONS

b

k

f

eell **TRY IT:** Trace over the gray letters to practice. Create your own letter in the blank spaces provided after the gray letters. Then try the variations.

Odd Cousins

These letters often require a little extra attention, since they have some unusual stroke patterns to master. The good news is, there are alternatives to the traditional cursive style so you can experiment to find what works best for your hand. As you can see in the samples on the following exercise, a printed version of these letters works fine when paired with other cursive letters.

Loop Variations

Try this subtle variation in the ascender loops derived from the graceful Copperplate style on the following exercise. This will help if your loops tend to be hard to control, too large, or irregularly slanted. The variation adds a slight pause and direction change: instead of going directly from the base line to the ascender line, stop at the waist line, slightly shift your angle outward, and form your loop. I usually don't take the time to do this in my everyday handwriting, but if I'm writing something fancier, I love to use these alternative loops. They are more elegant and will also give you a head start if you go on to study brush calligraphy or modern script lettering.

handwriting heroes

"Writing is a consequence of thinking, planning, dreaming," explains author Joyce Carol Oates, who writes out her books by hand. Elin Hilderbrand also composes her books, two novels a year, in longhand. Other bestselling authors who pen their books in handwriting are Amy Tan, James Patterson, Stephen King, and Danielle Steel.

ODD COUSINS

r s x z r s x z r s x z

r r r r r r

s s s s s s

x x x x x x

z z z z z z

VARIATIONS

s s s s s s s s

r r r r r r r

star star star star star star

rest rest rest rest rest rest

ꝭꝭ **TRY IT:** Trace over the gray letters to practice, then use the blank lines to try to write your own version of *star* and *rest*.

standard one step

e e l l f f h h k k b b

copperplate two steps

e e l l f f h h k k b b

or eliminate loops

l l h h k k k k b b

To be yourself,

just yourself,

is a great thing.

HENRY MILLER

TRY IT: Trace over the gray letters to practice. Then write the quote.

Underhand or Overhand Stroke Examples

Entrance and exit strokes in cursive letters are the lines leading into the letter or exiting after the letter is formed. The strokes can be written using two different orientations that can be described as *underhand* or *overhand.*

Practice these underhand and overhand strokes, as isolated strokes and in letters, until they feel natural and fluid. It's beneficial to know both of them, as the variety adds interest to fine handwriting.

- **Lines 1 and 2:** The two options apply to both the entrance and exit strokes of letters.
- **Line 3:** An underhand stroke is used for both the entrance and exit stroke of the letter.
- **Line 4:** This line uses an overhand stroke for both the entrance and exit stroke.
- **Line 5:** The entrance stroke is underhand, while the exit stroke is overhand.
- **Line 6:** An overhand entrance stroke introduces the letter, followed by an underhand exit.

Experiment with all these combinations in your handwriting to see what looks best—a lot will depend on the context of the letter. These strokes might not seem that exciting at first glance, but these simple variations provide an amazing opportunity to change up your writing.

After you master the basic entrance and exit strokes, there's room for adding personality. The strokes can be written with varying lengths, depending on their placement in the text. They are also the perfect spot for adding flourishing, as long as they don't interfere with legibility.

●✧ practice tips

Pangrams are sentences that use all twenty-six letters of the alphabet at least once. They are perfect for handwriting practice because you will be using each letter. Use these examples or make up your own pangram for an extra challenge!

The quick brown fox jumps over the lazy dog.

The five boxing wizards jump quickly.

How vexingly quick daft zebras jump!

ENTRANCE AND EXIT STROKE WARM-UPS

1. *underhand stroke*

2. *overhand stroke*

3. *a a g g f f y y z z*

4. *g g y y f f z z*

5. *g g y y f f j j*

6. *g g h h x x k k*

(You are enough)

TRY IT: Trace over the gray letters to practice. Then write the words
You are enough on a separate piece of paper.

a b c d e f g h i j k l m

n o p q r s t u v w x y z

s s s u v w y

b f k o o p p r r r

⸱ₑₑₗₗ **TRY IT:** Practice copying these lowercase letters.

the quick brown fox jumped over the lazy dog's back

TRY IT: Copy this pangram for extra practice.

*Talent is only
the starting point*

creativity takes courage

*arrange whatever pieces
come your way*

TRY IT: Copy these quotes for extra practice.

Uppercase Letters

Uppercase Warm-Ups

Like the lowercase warm-ups, these exercises will pave the way for you to form accurate letters later on. While the practice lines and shapes appear undecipherable, each one of them is actually part of an uppercase letter, and will help you break down the complexities of difficult stroke combinations. It's also helpful to review the exercises periodically as you work through the book; they are useful for warming up before more difficult practices. For strategic practice on letters that are difficult for you, pinpoint the exercises that correspond with those letters, and run through those more often.

Uppercase Families

The uppercase letters are divided into eight family groups, based on their similar features:

- Flagpole letters
- Round letters
- Reverse loop letters
- Fish hook letters
- Candy cane letters
- Ostrich fern letters
- Cinnamon rolls
- Odd cousins

Check out the variations also—it's good to have them in your toolbox to change things up, or to be able to find a better fit for a particular word.

You'll see that while the round letters are drawn in a counterclockwise motion, the reverse loop letters, *I* and *J*, are the opposite. This takes some practice to get used to, but skill in writing both directions comes in handy, especially when you start to add flourishing.

The first stroke of the candy cane, ostrich fern, and cinnamon roll letters are similar, but they have subtle and important distinctions. Each of these strokes is represented in these Uppercase Warm-Ups for you to practice if any of these letters feel challenging.

TRY IT: Practice tracing these lines on the gray versions. Extra lines are provided for more practice space.

FLAGPOLE LETTERS

These have a curved swoop up, like a waving flag, and a straight spine, like a flagpole.

VARIATIONS

_ℓℓℓ **TRY IT:** Practice tracing these letters on the gray versions. Extra lines are provided for more practice space.

ROUND LETTERS

The round letters all contain at least one curved line that is written with a counterclockwise motion.

A a A A A A

C C C C C C

D D D D D D

O O O O O O

E E E E E E

VARIATIONS

A A O O O

_eee **TRY IT:** Practice tracing these letters on the gray versions. Extra lines are provided for more practice space.

REVERSE LOOP LETTERS

These move clockwise, rather than the counterclockwise motion we use for the round letters.

ₑₑℓℓ **TRY IT:** Practice tracing these letters on the gray versions. Extra lines are provided for more practice space.

FISH HOOK LETTERS

These are named for the curved descending line that ends in a hook.

ₑₑℓℓ **TRY IT:** Practice tracing these letters on the gray versions. Extra lines are provided for more practice space.

CANDY CANE LETTERS

These start with a loop but have a straight back. You can see the candy cane shape in the base of the letter.

eeel **TRY IT:** Practice tracing these letters on the gray versions.

OSTRICH FERN LETTERS

These start with the same loop as the candy cane letters but descend in a reverse *S* shape.

VARIATIONS

eeel **TRY IT:** Practice tracing these letters on the gray versions.

CINNAMON ROLLS

These also start with the same loop but swoop all the way directly under the loop and make a comma shape.

VARIATIONS

eeee **TRY IT:** Practice tracing these letters on the gray versions. Extra lines are provided for more practice space.

ODD COUSINS

The odd cousins have eccentricities that don't fit into the other family groups. These interesting letters can require extra practice because their lines and shapes are not as common as those found in other letters.

G G G _____ G G _____ G G _____

L L L _____ L L _____ L L _____

S S S _____ S S _____ S S _____

ℓℓℓ **TRY IT:** Practice tracing these letters on the gray versions.

CAPITAL LETTER VARIATIONS COMBINED WITH LOWERCASE LETTERS

Writing is thinking on paper.

WILLIAM ZINSSER

One kind word can warm

three winter months.

JAPANESE PROVERB

ℓℓℓ **TRY IT:** Practice writing these quotes, which feature capital letter variations and combining lowercase letters.

Extra Practice

Uppercase letters, also called *majuscules*, are an exciting study in pos-sibilities. By allowing sufficient time to practice and master each family group, you'll have the tools to take your handwriting to the next level. If you find yourself struggling with the uppercase letters in your practice time, refer back to the exercises you just completed. They will help you with the correct stroke sequencing, which leads to fluid writing.

MAJUSCULES

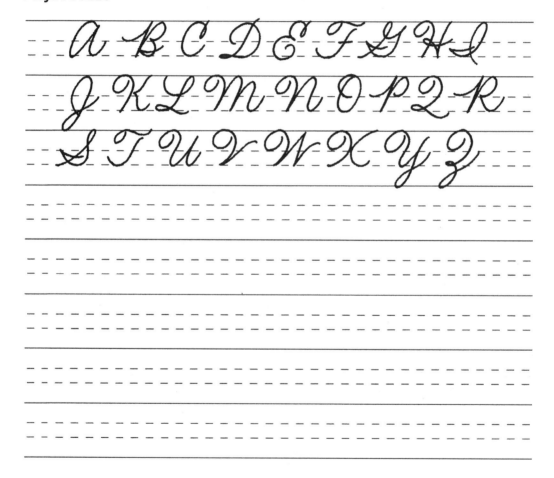

eell **TRY IT:** Practice writing all the capital letters.

When you have a handle on these basic capitals, the variations in the upcoming sections will give your handwriting extra flair and versatility.

MAJUSCULE VARIATIONS

A B E G I J O O
Q R S V X Y Z

_ℓℓℓ **TRY IT:** Practice writing the capital letter variations.

MAJUSCULE IN A QUOTE

What we learn with pleasure, we never forget.

_ℓℓℓ **TRY IT:** Practice writing this quote.

Capital Letter Variations

If you'd like to try your hand at other styles, following are several alphabet exemplars provided for you to practice recreating.

COPPERPLATE CAPITAL LETTERS

A B C D E

F G H I J K

L M N O P

Q R S T U

V W X Y Z

ꝃꝃꝃ **TRY IT:** Copy these Copperplate capital letters on the blank lines.

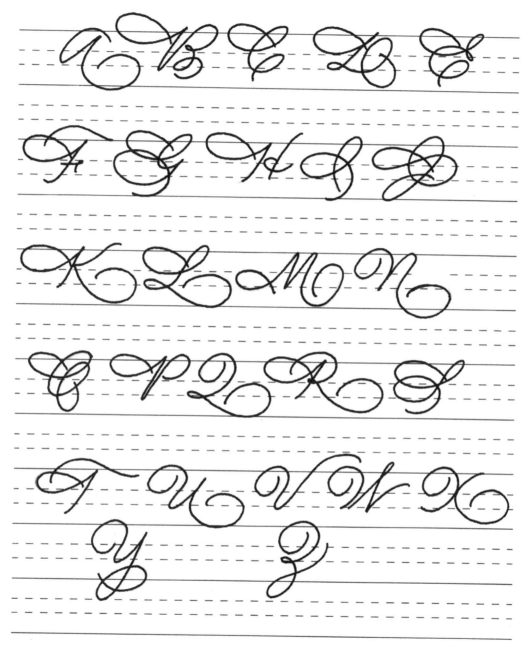

eeee **TRY IT:** Try writing these Spencerian capital letters.

SPENCERIAN LOWERCASE LETTERS

a b c d e f g h i j

k l m n o p q r s

t f u v w x y z

ɾɾɾℓ **TRY IT:** Copy these lowercase letters on the blank lines provided.

While the classic Copperplate and Spencerian hands are traditionally executed with a dip pen or brush marker that allows for thick and thin lines, all of these exemplars were done with the same width line (using a fountain pen) to make them accessible for you to use in your everyday handwriting. They can be used with whatever writing utensil you have on hand for signatures, letter writing, list making, taking notes, and journaling. You can pull from different styles to suit your preferences and abilities. Keep trying letters that seem "too hard" for you. You might be surprised to find that suddenly one day they are the perfect fit for what you are writing, or just what you need to get out of a practice rut.

A friend's eye is a good mirror

IRISH PROVERB

I cannot live without books

THOMAS JEFFERSON

TRY IT: Copy these quotes to practice Spencerian letters.

Other Capital Letter Variations

Here's another alphabet I compiled that is a simple yet elegant option. It's more similar to the Spencerian hand than the Copperplate hand, but has a less ornate, more minimalistic style. Sometimes you don't want to use fancy capital letters for your signature or other writing.

CAPITAL LETTER VARIATIONS

A B C D E F

G H I J K L

M N O P Q R

S T U V W X

Y Z Delightful

TRY IT: Practice this alphabet and, for more fun, use these simple, elegant capitals with words to discover your favorites.

When I practice different capital letter variations, I like to use them in a word to bring the letters to life and see how they "get along" with other letters. In the following pages of uppercase variations written with words, there are several styles of capital letters for you to practice in word form. Then, at the bottom of the exercises, try your own variations written with words.

CAPITAL *A* VARIATIONS

Artistic Always

Awesome Anniversary

Action Attitude

Angels Around

TRY IT: Copy these variations on the letter *A*.

CAPITAL *B* AND *C* VARIATIONS

Brave Beautiful Believe

Benevolent Brilliant

Breathe Bloom

Compassion Calm

Cupcakes Charisma

TRY IT: Copy these variations on the letters *B* and *C*.

CAPITAL *D*, *E*, *F*, AND *G* VARIATIONS

Decisive Dear Devoted

Energetic Equality Eager

Family Fantastic Friend

Forever Good Grateful

Grace Gorgeous

TRY IT: Copy these variations on the letters *D*, *E*, *F*, and *G*.

Happy Humor Healthy

Invincible Ideal Inky

Joyous Jolly Kindness

Knowledge Laughter Light

Love Magical Mindful

TRY IT: Copy these variations on the letters *H, I, J, K, L,* and *M*.

Nourish Natural

Open Organized Patient

Peaceful Pristine

Quiet Quintessential

Relaxed Rested Radiant

~eeel **TRY IT:** Copy these variations on the letters *N, O, P, Q,* and *R.*

Simple Significant Safe

Trust Travel Timeless

Winter Wisdom Write

Youthful Yesterday Yoga

Zestful Zany Zephyr

TRY IT: Copy these variations on the letters *S, T, W, Y,* and *Z*. (*U, V,* and *X* are not included because those letters aren't as common, and examples are found elsewhere in the book.)

Creative Endeavors

with Cursive

Joining Letters

While we probably don't give it too much thought, admirable hand-writing is marked by proper letter joins. With most letter combinations, joining the letters flows fairly naturally, but there are a few difficult letter joins that require extra thought and attention.

Twenty-two of the twenty-six letters have an exit stroke that starts at the base line. Because of this opportune placement, most of the letters in the alphabet lead in to the next letter fairly easily. If you'd like an exercise that tackles the alphabet systematically, you can write through all the possible pairs with each letter. I've provided two-letter combinations for all the vowels and for *p*, *r*, and *t* for you to trace and replicate to get you started. You can also practice letter joins with words and phrases. You'll see that the angle of the line connecting letters will change based on what type of join it is. Two parallel letters (like *t*'s and *l*'s) will require a differently angled join than a straight letter with a round letter (*t* and *o*, for example), or two round letters (*a* and *d*).

●◆ **fun facts**

Have you ever wondered about the common expression used to predict calamity, "I can see the handwriting on the wall"? This idiom originates from an ancient biblical story in the book of Daniel, written between the fifth and third centuries B.C., in which King Belshazzar was warned by a mysterious hand that appeared out of nowhere and scripted a prophetic message on the palace wall.

ab · · · · · ac · · · · · ad · · · · ·

ae · · · · · af · · · · · ag · · · · ·

ah · · · · · ai · · · · · aj · · · · ·

ak · · · · · al · · · · · am · · · · ·

an · · · · · ao · · · · · ap · · · · ·

aq · · · · · ar · · · · · as · · · · ·

at · · · · · au · · · · · av · · · · ·

aw · · · · · ax · · · · · ay · · · · ·

az · · · · · an apple a day · · · · ·

as happy as a clam · · · · ·

TRY IT: Practice writing these various letter joins. Then write the phrase.

ea eb ec

ed ef eg

eh ei ej

ek el em

en eo ep

eq er es

et eu ev

ew ex ey

ez ee ee

educate the heart

TRY IT: Practice writing these various letter joins. Then write the phrase.

ia ib ic

id ie if

ig ih ij

ik il im

in io ip

iq ir is

it iu iv

iw ix iy iz

What seems to us as

bitter trials are often

blessings in disguise.

OSCAR WILDE

TRY IT: Practice writing these various letter joins. Then write the quote on a piece of practice paper.

oa ob oc

od oe of

og oh oi

oj ok ol

om on op

oq or os

ot ou ov

ow ox oy oz

I can live for two months on a good compliment.

MARK TWAIN

TRY IT: Practice writing these various letter joins. Then write the quote.

ua *ub* *uc*

ud *ue* *uf*

ug *uh* *ui*

uj *uk* *ul*

um *un* *uo*

up *uq* *ur*

us *ut* *uv*

uw *ux* *uy* *uz*

the purpose of art is

washing the dust of

daily life off our souls.

PABLO PICASSO

eell **TRY IT:** Practice writing these various letter joins. Then write the quote on a piece of practice paper.

LETTER JOINS USING *P*

pa pb pc

pd pe pf

pg ph pi

pj pk pl

pm pn po

pp pq pr

ps pt pu

pv pw px

py pz

please pass the peas

_eee **TRY IT:** Practice writing these various letter joins. Then write the phrase.

ra rb rc

rd re rf

rg rh ri

rj rk rl

rm rn ro

rp rq rr

rs rt ru

rv rw rx

ry rz

perfect love drives out fear

ᵉᵉᵉ **TRY IT:** Practice writing these various letter joins. Then write the quote.

ta *tb* *tc*

td *te* *tf*

tg *th* *ti*

tj *tk* *tl*

tm *tn* *to*

tp *tq* *tr*

ts *tu* *tv*

tw *tx* *ty* *tz*

Never give up, for that is just the place and time that the tide will turn!

HARRIET BEECHER STOWE

TRY IT: Practice writing these various letter joins. Then write the quote on a piece of practice paper.

Letter Joins Using *b, o, v,* and *w*

The letters *b, o, v,* and *w* are the four letters that deviate from the norm. These letters have an exit stroke at the waist line—a small swooping stroke that looks like the smile on a smiley face. In spite of its happy shape, this exit stroke sometimes makes it difficult to connect with other letters of the alphabet. The key is to make this line distinct enough to maintain legibility as it melds with the next letter.

For example, take a look at the *b-e* combination in the following practice exercise. The exit stroke of the *b* becomes part of the loop of the *e,* but there is enough space between the two to distinguish the two letters. In the *b-r* combo, the angle of the exit stroke curves upward to allow for the first stroke of the *r.*

The *o-r* and *o-s* combinations are typically awkward. For legibility, both the *r* and the *s* work best starting at the base line, but here they are forced to start at the waist line. I find it helps to drop the exit stroke of the *o* a bit (just enough to not look like an *a*) to allow room for an exaggerated entrance into the *r* and the *s.* The *w-r* combo is similar.

Letters with Descender-to-Ascender Joins

Another letter connection to watch for is the descender-to-ascender join. For these letter pairs, your pen needs to travel from the descender line to the ascender line in one long movement, with the goal to keep this stroke smooth and steady enough to blend in with the rest of the word. The most common examples of this join are found in the *g-h, g-l,* and *y-l* letter combinations.

> **◗◆ handwriting heroes**
>
> Leonardo da Vinci (1452–1519) was left-handed, and wrote in a mysterious style of mirror-writing from right to left and backward. To be read normally, it needs to be reflected in a mirror. Several theories have emerged about why Da Vinci wrote in mirror-writing. One is strictly practical: as a lefty, he avoided smudging the ink. Another possibility is that by having to think about his backward writing, his brain may have been more likely to remember the content, a technique known as "reinforced learning."

ba be bi bl bo br bu

ba ba be be

bi bi bo bo

br br bl bl

oa oe oi or os ou ow ox

oe oe oi oi

or or os os

ow ow ox ox

wa we wo wy wr woo wh wi

wa wa wy wy

wr wr wo wo

wh wh wi wi

~~eeee~~ **TRY IT:** Trace these letter joins on the gray versions.

DESCENDER-TO-ASCENDER AND OTHER JOINS TO PRACTICE

by fl gh yl fr gr rs

by *by* *fl* *fl*

rs *rs* *gl* *gl*

gh *gh* *yl* *yl*

fr *fr* *gr* *gr*

sursum corda

hors d'oeuvres

you've got rhythm

TRY IT: Practice these letter combinations until you like their look and feel.

Extra Practice

Copying the words and phrases will help you test out various letter joins and build good habits. For extra practice, write all the words you can think of using the joins you find the most challenging. Letter joining and letter spacing are close cousins, since the angle of your join impacts the white space between your letters. Remember to analyze your spacing between the letters periodically while you practice, checking for consistency within and between the letters. I like to turn my page upside down to check spacing—it's a great way to get a fresh view of the white space, without the distraction of reading the words.

With concentrated effort, even the toughest letter joins will start to feel more natural. Your handwriting will be more legible and appealing. And you'll be rewarded with greater ease and speed in your writing.

If you want to make progress with a difficult letter, try this tip. For me, lowercase cursive r's are a difficult letter to master, so I like to write through the alphabet putting an r between each letter, for example: arbrcrdrerfrgr...

Using this method, you get a chance to practice the challenging letter in relation to other letters, and inadvertently find out which letter joins and spacing issues need the most attention.

PRACTICING A CHALLENGING LETTER

arbrcrdrerfrgrhrirjrkrlr

TRY IT: Practice by putting a letter you want to master between each letter in the alphabet.

Connecting Capitals with Lowercase Letters

When you look at your everyday cursive writing, do you typically join capital letters to lowercase ones, or lift your pen and leave a space between them? Either way is acceptable, and you'll likely find that you incorporate both methods, depending on the uppercase variation you choose and the combination of the two letters.

▼ Here are examples of the same name written two ways: first, with the uppercase and lowercase letter joined, and second, with a separation between the two letters.

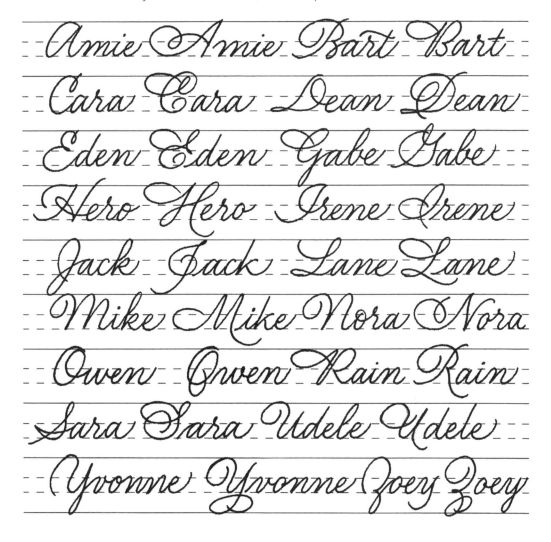

If your objective is to write quickly, you may prefer joining the capital to the lowercase letter to increase the flow of your handwriting. However, a pen lift after the uppercase letter and a break in the space before starting the next letter is more conducive to adding flourishing or other design elements. Keep in mind that some combinations of letters might not join as smoothly, such as a capital *F* followed by an *i*, as in *Fiona*.

▼ As you can see in this example, after the cross bar of the *F*, it makes more sense, and is more legible, to start fresh at the base line with the next letter.

When you are writing words with capital letters, keep your mind open to new ideas. I like to think of capital letters as the lead parts in a play, with great capacity to bring energy, creativity, and personality to a word or piece. They are also one of the most versatile aspects of handwriting. You can have a lot of fun with capital letters and still not compromise legibility.

It can be monotonous practicing lines of the same letter over and over. To make it more interesting, go through the alphabet using the names of people or places, such as Australia, Brazil, Canada...Zimbabwe! This way you will be practicing both uppercase and lowercase letters, and also working on spacing and joining letters.

◗◗ practice tips

Starting the letters at the correct spot and knowing the right direction and sequence of the strokes is helpful, although people have different preferences regarding this. You may find it's easier, for example, to start a stroke at the bottom, even though the traditional ductus shows the stroke starting at the top. You don't have to be a stickler about the rules; as long as the end result is legible, use the sequencing strategy that works most naturally for you.

Aria Beth Carl Dave

Evan Fern Gina Herb

Iris Jace Kate Levi

Mary Nina Otto Pavo

Quin Reed Seth Tara

Vera Wade Yana Zoey

TRY IT: Go through the alphabet and think of a name or place for each letter.

Common Pitfalls

Identifying and correcting some common pitfalls will bring steady improvements to even the most illegible penmanship. Understanding letter formation establishes a good foundation and naturally solves many problems related to messy penmanship. Recognizing particular areas to troubleshoot is the next step to reversing any bad habits you may have developed. Check a sample of your handwriting for any of the following:

Issue	Remedy
Not closing counters in letters like *a, o, g,* and *d.*	Review the following section "A Case for Closing Counters."
Cross bars and *i* dots forgotten or misplaced.	Be attentive when you are crossing *t*'s and dotting *i*'s; refer back to the letter joins pages for these letters and review the joins and practice quotes at the bottom of the pages. Generally slowing down while writing will give you more accuracy.
Inaccurate letter joins.	Review letter joins pages and exercises; memorize difficult joins and target practice time to these areas. Slow down when connecting letters to create muscle memory. I find that writing words, quotes, or song lyrics is more helpful (and interesting!) than just making pages of the same letters or letter joins. Have someone else look at your writing and clue you in on what words are the most challenging to decipher.
Letters not hitting the base line and getting confused with other letters; for example, if the last stroke of a lowercase *a* doesn't hit the base line, it will be confused with an *o.*	Follow the instructions for the remedy listed previously for inaccurate letter joins, and also use guidelines when writing. Analyze what letters typically give you trouble. When you spot them, take a few minutes to rewrite the sentences containing errors.

Issue	Remedy
Ascenders and descenders are too short and resemble other letters, or they are too long and tend to get tangled up in other letters.	Use guidelines with both the base line and the ascender/descender lines represented. Refer back to exercises for loop letters in the lowercase letters section. Pay close attention to your ascenders and descenders when writing; whenever you notice that your ascenders or descenders need adjusting, rewrite those words for extra practice.
Hand cramping.	Check your pen hold—are you using too much pressure? Lighten your grasp and make sure you are using a writing implement that performs well with less pressure. Practice regularly but take breaks often. Explore writing techniques that involve your wrist, forearm, and whole arm, not just your fingers.
Handwriting starts neat and gets messier.	Take breaks, practice regularly to build endurance, continually look to the first line as a standard for the rest of the page. Do you tend to rush as you move down the page? Watch your pace to ensure it is slow enough to maintain neat writing.
Letters that could have a confused identity. Here's a small sampling of some letters that are commonly mistaken: *a* and *u*, *e* and *l*, *o* and *a*, *h* and *b*, *r* and *n*, *n* and *m*, *y* and *g*, *u* and *w*. A double *r* can be misconstrued as a *u*. Putting a loop in the stem of the lowercase *t* can make it look like an *l* if the cross bar is forgotten or misplaced.	After you determine what letters affect the legibility of your writing, review the forms of these letters and any warm-up exercises associated with their strokes. Practice them alone, with letter joins, and in words and sentences. As you choose creative practice ideas throughout the book, tackle these problem areas day by day through reviewing and rewriting your work. This intentional ongoing process will break poor habits and build new ones.

A Case for Closing Counters

Counters are the enclosed spaces in letters like *a* and *o*. Not closing counters completely is a common problem in handwriting and makes a big difference in legibility, but it's easy to fix. Take a look at a sample of your regular handwriting to see if this is something you might need to work on. Since letters with counters closely resemble some letters without counters, they create the most common identity issues if they aren't written distinctly.

Check the following examples for some of these typical mistaken identities in lowercase letters. If the counter isn't closed, an *a* can look like a *u*, a *b* can look like an *h*, the *d* can appear to be a *cl*, an *e* can look like a *c*, and a *g* can resemble a *y*. To correct, slow down when you get to the letter, and make note of where you are starting the first stroke. Experiment with tweaking the starting stroke to make it easier and more natural for you to close off the counter. For example, starting the *a*, *d*, and *g* a little farther to the right will make it easier to close the counter before starting the next stroke or exiting out of the letter. Rather than making a downstroke right away, you'll make a left to right rainbow shape before moving down and around to create the counter.

On the closing counters page, you'll see some of the common ways a letter is written, then a corrected version following. Complete the rainbow (left to right) and loops exercise before moving on to work on letters with counters. You can also add *o*, *p*, and *q* to your practice if you wish.

●◇ fun facts

Graphology, the study of handwriting, interprets the personality and aptitude of individuals by analyzing their handwriting. Graphotherapy is the practice of making changes in handwriting to achieve a more desirable life. For example, *T*-crossings that sag downward indicate a gullible and indecisive personality trait. By intentionally leveling the cross bars, proponents of graphotherapeutics believe that subconscious attitudes and behaviors will shift to become more discerning and self-assured.

a a d d g g

e e b b o o

e e e e e e e e e e e e

a a a a a a a

d d d d d d d

g g g g g g g

e e e e e e e

b b b b b b b

TRY IT: Practice fully closing these letters on the gray versions.

A Final Note on Troubleshooting

Look at your writing and note anything you'd like to change. Maybe you think your letters are too scrunched, making them hard to distinguish, or that your letter joins look choppy or unsophisticated. Connecting letters for cursive can be awkward if you haven't had a chance to adequately learn the strokes and angles of letter joins. You might notice that you tend to use a hodgepodge of cursive, printing, and lowercase and uppercase letters that make your writing appear disjointed or difficult to read.

After you uncover your specific challenges, write down the specific goals you have for your handwriting adventure. Besides what you want to accomplish, reflect on why these goals are important to you. Keep this "why" in the forefront of your mind as an antidote for any hurdles that may pop up along your journey. Most importantly, even though it's work to leap hurdles and avoid pitfalls, revel in the charming landscape of handwriting, celebrate the process wherever you find yourself, and have fun! Enjoyment is the ingredient that will make everything you learn stick with you.

Everyday Handwriting Samples

1. In the first word, *and*, the *a* could be confused with an *o*. The *d* has an open counter and looks like *cl*. In the second word, *our*, the *u* looks like an *o* or an *a*. Eliminating the loop will help.

2. In the word *lazy*, the problem is with the letter join between the *a* and the *z*: the second stroke of the *a* needs to come down to the base line.

3. The word *here* looks like *lure*. The *h* is unclear and the first *e* needs a more pronounced counter.

4. The word *going* needs a closed counter on the last *g* so that it doesn't look like a *y*. The *i* and *n* letter shapes and joins need to be a little cleaner for increased legibility, as well as the placement of the dot for the *i*.

5. *Little* is a tricky word with three ascenders in a row. Consistent loops help legibility, as does making sure the counter letters, such as the *e* in this case, have a visible, closed counter. The first *e* in *better* also needs a counter, so that it isn't confused with an *i*.

6. The words *arrived* and *house* need more pronounced counters for the letters *e* and *d*. The double *r* looks like a *u*, and the *s* needs to be closed before the letter join with the *e*.

7. In the word *healthy* the *e* would be more clear with a loop, and the counter on the *a* needs to be closed to avoid confusion. Also, in both *h*'s the ascender could be lengthened for increased clarity. The *t* to *h* join is missing an upward stroke, which makes the *h* appear to be an *n*.

What to Do with Double Letters

Double letters appear often in the English language—literary twins that show up in names, titles, businesses, and more. In handwriting, there's a pronounced fork in the road when we encounter double letters. Let's take a look at a couple different paths we can take.

One is the identical twins route. When we take this course, we decide to make those two letters look as uniform as a set of twins we can't tell apart. In the context of some writing, especially if legibility and formality is of utmost consideration, this choice might be the natural way to go. I often prefer to take the identical route when I come across double vowels or, depending on the setting, certain letters like c, r, or z.

The second route is the fraternal twins route. You can see a simple example of this in the word *affirm*.

affirm

This approach takes advantage of the vast array of options for "dressing twins in different outfits" by contrasting their heights, loops, hills, and flourishes so they share similarities but march to the beat of their own drummer.

In the following image, you can see several words written twice. In the first rendition of the word, the double letters are written as similarly as possible, while in the second, care is taken to give each twin its own unique look. Sometimes, different sizes accomplish this. Generally, it works best to make the first of the double letters larger, but you'll also see examples that don't follow this rule. Sometimes the twins are very similar but start at different heights. Flourishing one letter, while the other remains relatively uncomplicated, is another way to bring variety to double letters.

▼ Examples of flourishing double letters.

Bookkeeper Bookkeeper

Fluffy Fluffy

Terracotta Terracotta

Balloon Balloon

Summit Summit

Practicing Double Letters

Practice all the words in the previous example, trying both approaches. Do you have a preference for one method over the other?

Write both of the happiness quotes in the exercise on the following page. In the first quote, the double letters are identical, while the second quote shows slight variations in the twins by writing the second letter a bit smaller than the first.

For further practice, copy the page of double letter animals later in this section, or choose a category that interests you and brainstorm all the double letter words you can think of. You'll find that certain letter pairs work better with one of the two approaches, so take your time to play around with what looks the best to you. Always keep legibility in mind, especially when adding flourishes or unique letter forms—you want your finished word to be easy to read.

Even though they require some extra atten-tion, I love how double letters are one of the tell-tale indications that a word was written by hand. They offer great opportunities for cre-ativity and exploration, so take advantage of them by trying new things when you see them coming.

For extra practice with flourishing options, following are more examples. These words use the common double letters of *d*, *p*, *f*, *t*, *g*, and *l*. All your practice will equip you with plenty of fun ideas to give your handwriting a little extra pizzazz. Now, there are some double *z*'s for you!

●◆ fun facts

Do animals write love letters? On a deep sea dive, Yoji Ookata spotted a mysterious *O*-shaped design on the ocean floor, and later discovered it was made by the pufferfish. This small fish diligently works day and night to carve an ornate circular pattern, using his flapping fin as a writing instrument. The fin-ished design, embellished with sea shells, is about 6 feet in diameter. Scientists observed that the more elaborate the design, the greater success the puff-erfish had in attracting a female.

happiness can exist only in acceptance.

GEORGE ORWELL

happiness lies in the joy of achievement and the thrill of creative effort.

FRANKLIN D. ROOSEVELT

ℓℓℓ **TRY IT:** Copy these quotes to practice using identical second letters and varied second letters.

otter

grasshopper

giraffe

loon

hippo

butterfly

rabbit

aardvark

squirrel

caterpillar

gazelle

kangaroo

TRY IT: Copy this page of animal words with double letters on a piece of practice paper.

Wedding gladden

happiness napping

truffle taffy

written Attractive

hygge treehugger

Allegro calling

eell **TRY IT:** Copy this page for more double fun on a piece of practice paper.

The Ups and Downs of Flourishing

Flourishing is a very gratifying aspect of handwriting. It gives penman-
ship more radiance, more flair. Flourishes are like fashion accessories
for letters. Like jewelry, scarves, and shoes, flourishing can tie a piece
together and create the wow factor that brings basic to the next level.

dreamy

Flourishing is a paradox of thought and planning with spontaneity
and freedom. It's one important facet that sets handwriting apart from
type. Even with frilly fonts, a computer key simply can't deliver what a
human hand can when it comes to flourishing.

While its end result is gorgeous, flourishing is a skill that requires practice, patience, and flexibility. Eventually you will adopt a style of flourishing with your own brand of creativity and individuality at play, but to start with, here are a few tips to keep in mind:

1. **Legibility is of utmost importance.** The goal of flourishing is to enhance the words and their meanings. Words play the starring roles on the "stage" of your page, so check to ensure that flourishes don't distract from them. Also, flourishes can sometimes look like letters if they are at the beginning or end of words. Because it's often hard to accurately assess your own work, it helps to run your flourished words by a pair of fresh eyes and let someone else clue you in on its readability.

2. **Flourishes should be oval or rounded in shape, and smoothly executed.** Try to avoid irregular shapes and other ungainly lines and crossings that interrupt the flow of the words. A good rule of thumb is to aim for lines to cross at 90-degree angles, or as close to that as possible.

3. **Practice flourishes in pencil.** Good flourishing requires strategic planning—it rarely just happens naturally. At the same time, allow yourself to try some wild, new things when you flourish. Those flourishes might surprise you with how well they work.

4. **Think big.** When creating larger, sweeping flourishes, utilize your whole arm, not just finger movement, for a more natural-looking effect.

5. **Strive to achieve balance when you are flourishing.** Words like *Friday*, which contain both an ascender and descender nicely spaced, are ideal for flourishing practice since balance is more easily attained. When handwriting several lines, it usually works best to keep the flourishing on the outside edges of the words, rather than in between lines where it can be hard to read if it gets too crowded. Start small. A little flourishing is better than too much.

Where do flourishes fit best in handwriting? Ascenders and descenders offer perfect opportunities to add some embellishment. Capitals are conducive to flourishing, as well as letters with cross bars. The beginnings and ends of words also work well, and these flourishes are especially helpful when you are working to create the balance mentioned earlier.

ASCENDER AND DESCENDER FLOURISHES

_ℓℓℓℓ **TRY IT:** Try mirroring these flourishes on a piece of practice paper.

there is nothing
on this earth
more to be prized
than true friendship!

THOMAS AQUINAS

TRY IT: Try to copy this simple quote about friendship. In this example, the ascender and descender flourishes are reserved for the outside of the piece, rather than the middle lines, for visual clarity.

Next, copy a couple more sets of quotes. Again, you'll notice how the flourishing is only used on the top, bottom, and sides of the page, so legibility is not jeopardized.

W, Y, A, F, AND Y FLOURISHES IN QUOTES

*We know what we are
but know not
what we may be.*

*Action is the
foundational key
to all success.*

TRY IT: Try writing these quotes on a piece of practice paper.

Friendship doubles our joy and divides our grief.

A faithful friend is the medicine of life.

TRY IT: Try writing these quotes on a piece of practice paper.

The following exercise with the words *chocolate* and *beautiful* shows a progression of flourishing, from simple to more elaborate. Trace these, then pick some words to make your own advancing levels of flourishing. This is an exercise I use consistently to explore flourishing options and push my imagination. You never know what you'll like until you try!

As the exercise on the following page shows, writing names is a strategy I use consistently to explore flourishing options and push my imagination. Experiment to discover your favorite flourishes. Flourishing comes in handy when you're writing names on envelopes, gifts, and place cards. Feel free to make your own personalized list of names to flourish as well.

Flourishing is also useful for emphasizing words and expressing the emotion of a piece, as seen in the quote about romance later in this section.

Be patient, and don't expect your flourishes to come together right away. Sometimes I'll go through several sheets of notebook paper before something clicks and I'm happy with the end result. Enjoying the trial-and-error process and keeping a sense of humor about the mess-ups will replace frustration with fun and fulfillment.

●◆ handwriting heroes

Want to combine handwriting with recycling? Emily Dickinson (1830–1886) did just that when she meticulously saved envelopes that came in the mail and jotted poems on them. The envelope poems are reproduced in the book *The Gorgeous Nothings: Emily Dickinson's Envelope Poems*. On one triangular back flap of an envelope, she wrote these lines:

"In this short Life /
that only lasts an hour /
merely / How much—how /
little—is / within our /
power."

PROGRESSION OF FLOURISHES

chocolate *chocolate*

chocolate *chocolate*

Chocolate *Chocolate*

beautiful *beautiful*

beautiful *beautiful*

Beautiful *Beautiful*

TRY IT: Trace these words, then pick some words to make your own advancing levels of flourishing.

TRY IT: Trace these names, then pick some names to make your own advancing levels of flourishing.

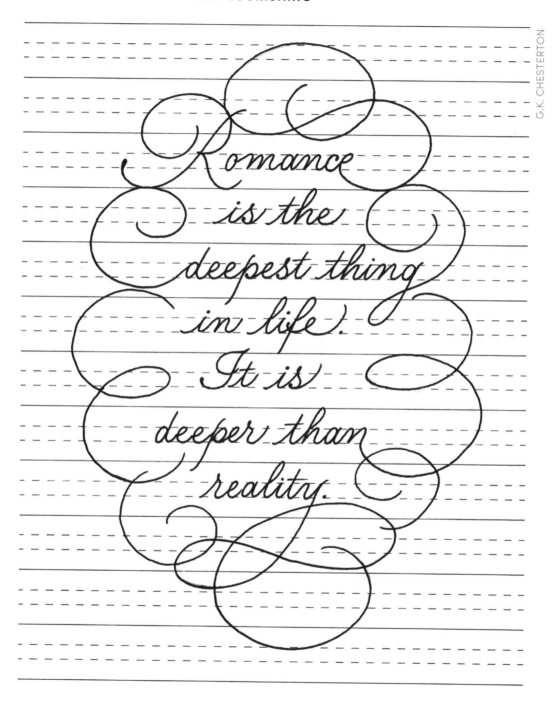

G.K. CHESTERTON

Romance is the deepest thing in life. It is deeper than reality.

TRY IT: Trace this quote, then pick some quotes to make your own advancing levels of flourishing.

Signatures: What's in a Name?

Why continue teaching penmanship in schools? One common argument is so that kids can learn to sign their names and read the signatures of others. A signature is simply the distinct way in which you script your name. Because of the intrinsically personal element of handwriting, a signature is a means of identification. Modern technology has replaced the need for signatures in some transactions, but signatures are still used for signing checks, legal documents, works of art, and correspondence.

Signatures are the kind of storytellers that do just what our English teachers incessantly reminded us to do: show, don't tell. When we see the signatures of people we are close to, those simple scripted names have power to conjure up so much more about them than the names involved. Things like emotion and personality and memories are mysteriously linked to the technicalities of letter formation. Following are signatures I wrote as examples, not actual autographs.

Now, it's time to work on your own name on the following page. Take advantage of the letters that you like in your name and identify any elements that cause you angst. You may want to try adopting some of the capital letter variations you have learned. You might also attempt other strategies you've explored in this book that apply to your signature, such as dealing with double letters, ascenders, descenders, and cross bars. Experiment with a minimalist signature in contrast with a flourished version. If you don't already have them, find reasons to love your signature. It's truly yours!

●◖ handwriting heroes

Do you have lots of different ways you sign your name? You're not alone, joining ranks with none other than William Shakespeare. We only have six surviving signatures belonging to the famous playwright, and each one is extraordinarily different! Charles Hamilton, who wrote an entire book devoted to understanding Shakespeare through his life and handwriting, explains that "a profuse variety of different handwritings and signatures can be the mark of an imaginative and highly intelligent person."

Yours Truly

Flannery O'Connor

Robert Frost

Emily Dickinson

Amy Carmichael

Walt Whitman

TRY IT: Copy these simulated signatures on a piece of practice paper.

DESIGNING AND EMBELLISHING YOUR OWN SIGNATURE

_eell **TRY IT:** Fill a page with your own signature.

Roman Capitals

The Impressive Roman Capital Letters

Because of their ubiquitous presence in our daily lives, it's easy for us to take Roman capitals for granted. But the fact that these letter forms are the foundation for our alphabet speaks of their enduring and powerful quality. In fact, their impressive design, dating back well over two thousand years, provides a window into the power and majesty of the ancient Roman Empire. At that time in history, the letters were brush-drawn and then cut in stone with a chisel and mallet. A few of the most famous inscriptions of Roman capitals can be seen in the Trajan Column, the Arch of Titus, and the Roman Pantheon.

Tips for Mastering Roman Capitals

Roman capitals are clean and basic, but it takes a lot of skill to write them well. Therefore, don't expect to master them in a short amount of time. Be patient with yourself and try not to rush your practice. Here are a few things to keep in mind as you practice Roman capitals:

- **Respect the proportions.** Learning the proportions of each family group will give you an underlying foundation for writing that will revolutionize your understanding of letters and your ability to produce stellar ones.
- **Look for straight lines and circles.** Identifying these key parts of each letter will help you break it down into smaller chunks as you learn.
- **Connect the dots.** When you construct your own letters, draw a few dots in key spots first, and then connect them. This will help take the guesswork out of where the strokes should start and end, and give you the guidance needed to make accurate forms.

●◆ fun facts

If the letters of the alphabet had a popularity contest, who would win? Based on the most frequently used letters in common speaking and writing, the most popular letter is *E*, followed by *T, A, I, N, O,* and *S*. The least popular is *Z*, followed by *J, X, Q, K, V,* and *B*. Can you guess which letter begins more words than any other letter? It's the letter *S*, and, not surprisingly, *X* ranks last.

Use the dots until you feel comfortable forming the letters without them.

- **Observe Roman capitals wherever you go.** They are on wine bottles, signs, posters, menus, magazines, book covers, and logos, to name a few. Note the versatility they offer, and the respect they command.
- **Use graph paper whenever possible for practicing.** Until you have a good handle on the proportions and can maintain them consistently, the grid lines will help keep your letters straight and even.

Because of the precision and discipline required to learn Roman capitals, your work with them will also help every other style of writing become easier to learn. And for an added bonus: it will provide you with the foundation necessary if you someday decide to take the next step to learn broad-edged or brush-lettered Romans with their thick and thin strokes and elegant serifs (those accents at the edges of letters). In the meantime, the monoline Romans we practice here, also called Skeleton Roman letters, are a useful and beautiful addition to your handwriting repertoire.

The Family Groups

Roman capitals can be divided into four family groups based on how much space in a square box they use.

- Whole-square letters
- Half-square letters
- ¾-square letters
- Narrow and wide letters

Whole-Square Letters

The first group is comprised of round letters that encompass either the whole square or most of it. These letters will use the entire height of the square and most or all of the width as well. The *O* and the *Q* use the entire square, while the *C*, *D*, and *G* use ⅞ of the square. The *D* and *G* use a straight edge for a portion of the letter. These letters are excruciatingly tough ones, and when you make one that you are proud of, take a moment to savor the goodness!

Half-Square Letters

The second group of Roman capitals uses half of the width of the square. This family contains the eight letters *L*, *F*, *E*, *K*, *B*, *P*, *R*, and *S*. I've divided the half-square letters into two types: *L*, *F*, *E*, and *K* are similar in that they consist of only straight lines. *B*, *P*, *R*, and *S* use both straight and rounded lines.

In the *E*, the bottom line extends out slightly beyond the top line to keep the *E* from looking like it may topple over. The middle cross bar of the *E* is a bit above the center line, unlike the *F*, in which the middle cross bar is exactly centered. Both of these placements are designed to create a balanced appearance. The bottom diagonal of the *K* also kicks out farther than the top arm, to keep the letter from looking imbalanced and top heavy.

In the half-square letters with a rounded section, the bottom portion of the *B* extends a little beyond the first section, as does the bottom portion of the *S*. It may look equally balanced to the eye, but when you turn the page upside down, you will see more clearly that the bottom half of

the *S* is larger to give the letter strength and stability. Like the *K*, the foot of the *R* also kicks out a bit to support the top half of the letter.

¾-Square Letters

The next family group of Roman capitals contains nine letters that occupy ¾ of the square. I've divided these letters into three subgroups to help you remember them better.

- The first subgroup (*H, U, T*) mostly contains straight lines, except for the rounded portion of the *U*.
- The second subgroup (*V, A, N*) has a few items to note. The *A* is an upside-down *V* with a cross bar placed one grid section below the center of the square. This creates visual balance. The *N* is similar to the *H* with two identical sides to the rectangular shape. The difference is that instead of the middle cross bar of the *H*, the *N* has a diagonal line starting at the top left and moving down to the bottom right-hand corner of the letter.
- The third subgroup of ¾-square letters is the last three letters of the alphabet (*X, Y, Z*). Like the *S*, if you turn the *X* upside down, you will see that the bottom part is larger than the top. To create this balance, move the top lines of the *X* in just a little bit from the ¾ marks of the bottom lines. This will cause the *X* to cross just slightly above the middle line. The two arms of the *Y* meet just above the center point of the square, where the bottom stem of the *Y* joins them. This positioning helps to create a stable base for the top of the *Y*. Similarly, the bottom line of the *Z* is just slightly longer than the top line, again for balance and visual appeal.

Narrow and Wide Letters

The fourth group of Roman capital letters has both extremes: the two narrow letters, *I* and *J*, and the two wide letters, *M* and *W*. The *J* has two variations you can choose from; one extends outside the square and one does not. The two outer lines of the *M* extend just beyond the grid square on each side. The *W* is not an upside-down *M*. The proportions are notably different, with the outer lines of the *W* extending out farther on each side.

WHOLE-SQUARE ROMAN CAPITAL LETTERS

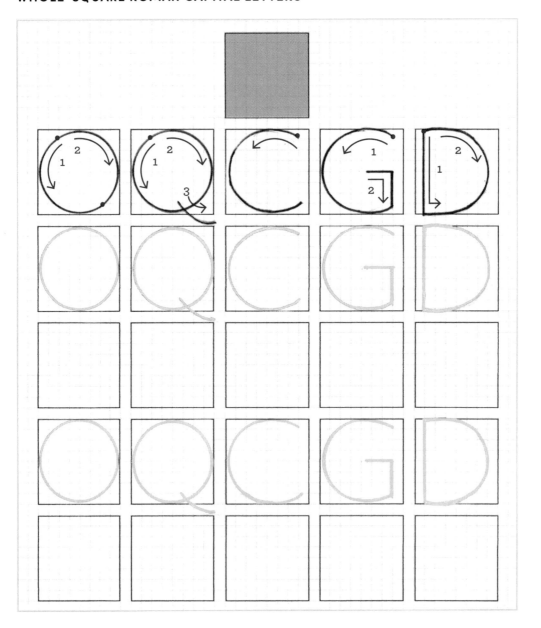

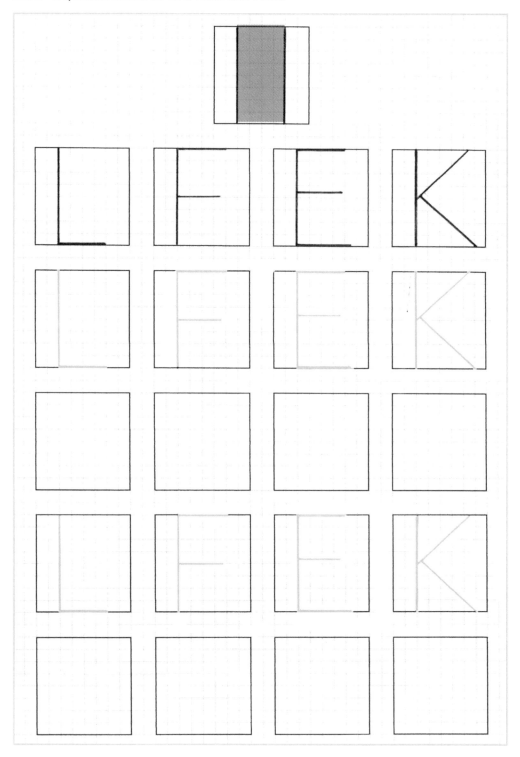

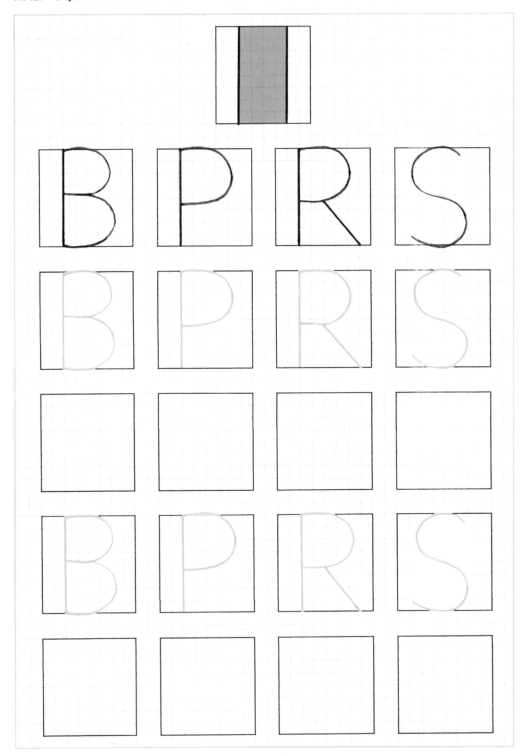

¾-SQUARE ROMAN CAPITAL LETTERS SUBGROUP 1

Spacing the Roman Alphabet Properly

Spacing is another tricky part of learning Roman letters, but when you practice with words and phrases, instead of just isolated letters, you'll have great opportunities to practice spacing between letters and words.

When spacing Roman capitals, you will need to consider what letter comes next in order to decide how much space to leave. Two round sides need to be placed closer together than a rounded side next to a straight edge. And two straight edges will need more space between them than either of the previous two examples. This is because you want to consider the volume of the space left between the letters. If you envision this space as a vase filled with water, you will want all the vases to hold about the same amount of water. This requires practice.

▼ In the first example of each word, the spacing does not work well. The second example shows a better attempt at handling the spacing issues.

The Whole Roman Alphabet

Here is the entire Roman alphabet in order for your reference.

ROMAN CAPITAL ALPHABET

eeee **TRY IT:** Copy the alphabet onto the blank squares provided.

Spacing Exercises

After you've gained confidence with your spacing, try replicating the following quote exercises. You can be creative in your use of cross bars and double letters, and also in designing compositions that use complementary styles of writing. Sometimes pairing Roman capitals with script or italic print adds emphasis and interest to a piece. Try designing your own piece using some of these elements and see what you come up with. Most importantly, have fun and enjoy the process.

THE MIND
WAS BUILT FOR
MIGHTY FREIGHT

EMILY DICKINSON

DETERMINATION

TRY IT: Copy this quote and the word *determination* to practice
spacing with Roman letters.

IT'S NOT WHAT
YOU LOOK AT
THAT MATTERS,
IT'S WHAT YOU SEE

HENRY DAVID THOREAU

eeee **TRY IT:** Copy this quote to practice spacing with Roman letters.

The secret of

PATIENCE

is to do something else

in the meantime.

eell **TRY IT:** Copy this quote to practice Roman letters with italic print mixed in for flair and effect.

ELEANOR ROOSEVELT

YOU MUST
do the thing
YOU THINK
YOU CANNOT DO

TRY IT: Copy this quote to practice Roman letters with cursive mixed in for flair and effect.

Getting Started

Cursive

Printing

Putting It All Together

Italic Print

Lowercase Italic Letters

Italic print is slightly slanted, highly legible, simple to execute, and pleasing to the eye.

LOWERCASE ITALIC WARM-UPS

ellℓ **TRY IT:** Copy these markings on the gray versions to practice the straight, curved, and rounded forms you'll be making for italic letters.

LINE-BASED LETTERS

line letters i j t l f

i i i i i i i

j j j j j j j

t t t t t t t

l l l l l l l

f f f f f f f

lift jit till fit

jill fill tiff lit

eeeQ **TRY IT:** Practice tracing the letters on the gray versions, then write the words on the lines provided. When making the line letters, remember to make the spine of the letter straight, and add the curve toward the very bottom of the line.

rounded letters o c e s

o o o o o o o

c c c c c c c

e e e e e e e

s s s s s s s

TRY IT: Practice tracing the letters on the gray versions. Note that the rounded letters are more oval than circular. Extra lines are provided for more practice space.

up arrows a d g q u y

a a a a a a a

d d d d d d d

g g g g g g g

q q q q q q q

u u u u u u u

y y y y y y y

ⅇⅇⅇ **TRY IT:** Practice tracing the letters on the gray versions. The up-arrow letters have a triangular shape of white space from the base line up to the waist line. This shape is like an arrow pointing upward, and gives the letter breathing room. Extra lines are provided for more practice space.

down arrows bp rkhmn

b b b b b b b

p p p p p p p

r r r r r r r

k k k k k k k

h h h h h h h

m m m m m m m

n n n n n n n

TRY IT: Practice tracing the letters on the gray versions. The down-arrow letters are similar to the up-arrow letters, except the triangular shape is inverted, with the point at the base line. This low branching makes the letters appear more light and airy. Extra lines are provided for more practice space.

work is love
made visible

KHALIL GIBRAN

well done is
better than well said

BENJAMIN FRANKLIN

TRY IT: Copy these short quotes to practice up- and down-arrow letters and rounded letters.

diagonals v w x z

v v v v v v v

w w w w w w w

x x x x x x x

z z z z z z z

variations a g k y w

turning it over

in your mind

won't plow the field

IRISH PROVERB

TRY IT: Practice tracing the letters on the gray versions. Diagonal letters contain one or more lines that are written at a pronounced diagonal slant. These lines may be upstrokes or downstrokes, but they don't follow the slight slant of the line letters, such as *l* and *t*.

Uppercase Italic Letters

The uppercase italic letters are also divided into family groups: line, line and curve, rounded, and diagonal letters.

LINE LETTERS

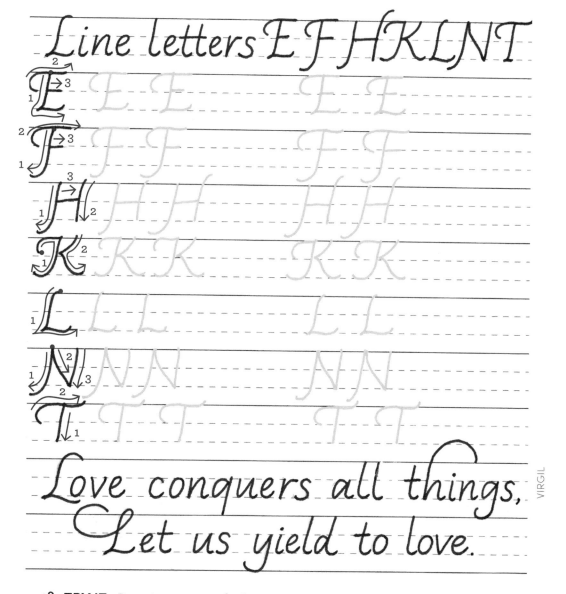

〰️ **TRY IT:** Practice tracing the letters on the gray versions. Copy the quote on a piece of practice paper.

Line & Curve I J U B P R

I I I I I

J J J J J

U U U U U

B B B B B

P P P P P

R R R R R

Pray devoutly
But hammer stoutly.

ENGLISH PROVERB

TRY IT: Practice tracing the letters on the gray versions. Write the quote on the blank lines provided.

Rounded OQCDGS

O O O O O

Q Q Q Q Q

C C C C C

D D D D D

G G G G G

S S S S S

Simplicity is the
ultimate sophistication.

LEONARDO DA VINCI

ℓℓℓ **TRY IT:** Practice tracing the letters on the gray versions. Write the quote on the blank lines provided.

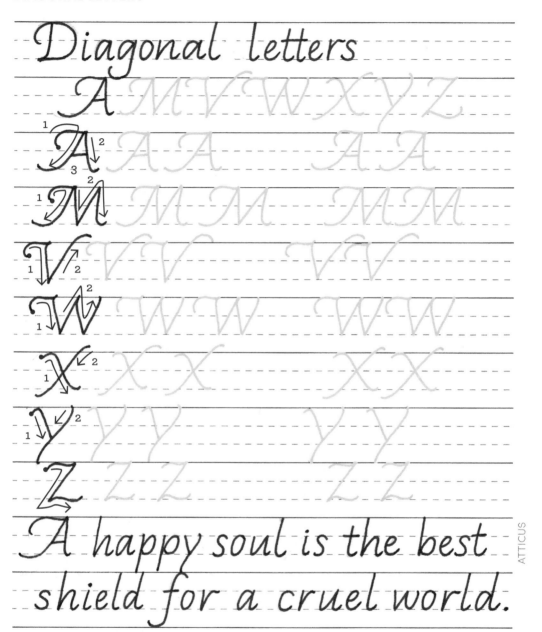

Diagonal letters

A M V W X Y Z

A A A A A

M M M M M

V V V V V

W W W W W

X X X X X

Y Y Y Y Y

Z Z Z Z

A happy soul is the best shield for a cruel world.

ATTICUS

🌀 **TRY IT:** Practice tracing the letters on the gray versions. Write the quote on a piece of practice paper.

Italic Alphabet

This is an all-around great alphabet to master for its clarity and simplicity. After you've practiced the letters alone in the previous exercises, use them in the quotes provided next. They get along beautifully with Roman capitals and can be flourished similarly to script.

ITALIC ALPHABET

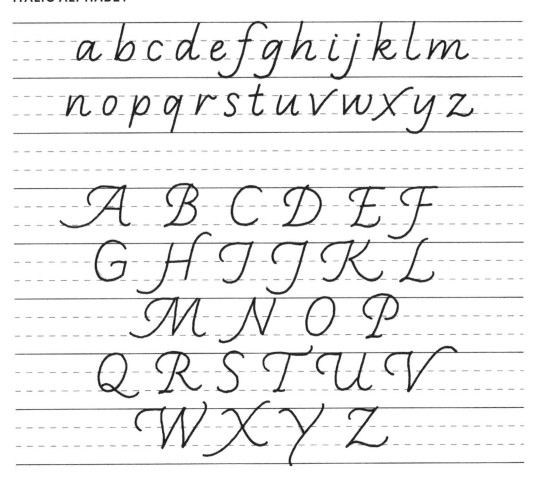

ℓℓℓℓ **TRY IT:** Practice copying the alphabet on a piece of practice paper.

I with you,
and you with me,
Miles are short
with company.

GEORGE ELIOT

Not all who
wander are lost.

J.R.R. TOLKIEN

ell **TRY IT:** Copy the quotes, mixing up the alphabets if you prefer.

Creative Endeavors
with Printing

Mixing Up Your Printing Style

Realistically, you won't always have time for the exacting Roman cap-
itals, and it's fun to supplement the italic hand with some alternatives.
Luckily, your printing style can be changed up in myriad ways.

Alphabet Variations

Simply by varying the height and width of a print style, you'll create a
completely different look. Cross bars on the A, E, F, and H can be cen-
tered or positioned high or low. They can be straight or wavy. Letters can
be upright or slanted to all different degrees to offer even more variety.
Adding serifs (projections that finish off the ends of strokes) is another
way to alter the personality of an alphabet. You can also vary the spac-
ing by making the letters tight or spreading them out.

For extra practice, create your own alphabets, serif and sans serif,
using some of the stylistic variations mentioned above. One possibility is
shown on the following page.

▼ Which do you prefer: serif or sans serif?

A B C D E F G H I
J K L M N O P Q R
S T U V W X Y Z
a b c d e f g h i j k l m n o
p q r s t u v w x y z

A B C D E F G H I
J K L M N O P Q R
S T U V W X Y Z
a b c d e f g h i j k l m n
o p q r s t u v w x y z

A B C D E F G H I J K L M

N O P Q R S T U V W X Y Z

ABCDEFGHI
JKLMNOPQ
RSTUVWXYZ

eeel **TRY IT:** Try copying these uppercase letter variations on the blank lines provided.

Practice Quotes

Following are quotes you can use to practice these alternative alphabets. Review the same tips you used with cursive and increase your flourishing finesse by taking advantage of ascenders, descenders, cross bars, downstrokes, and wherever else you can flourish and still maintain legibility.

STYLISTIC QUOTE 1

DO JUSTLY.

LOVE MERCY.

WALK HUMBLY.

THIS IS

ENOUGH

JOHN ADAMS

TRY IT: Copy the quote for practice with alphabet variations.

BELIEVE THERE IS
A GREAT POWER
SILENTLY WORKING
ALL THINGS FOR GOOD

BEATRIX POTTER

ABCDEFGHIJKLM
NOPQRSTUVWXYZ

TRY IT: Copy the quote and alphabet for practice with alphabet variations.

Almost Everything has already been done, but it hasn't been done by you and that's all that matters.

ADAM SMILEY POSWOLSKY

TRY IT: Copy the quote for practice with alphabet variations.

Mixing Print and Script

Now, find a favorite expression, poem, or excerpt and create a composition that incorporates print and script. And of course, don't forget about all the flourishing possibilities. Mixing print with cursive looks great in compositions when the text is conducive to blending a couple of styles together, as seen in the following example.

▼ This design technique helps break up longer pieces of text or emphasize particular letters or words.

OUT BEYOND
THE IDEAS
OF WRONGDOING
AND RIGHTDOING,
THERE IS A FIELD.
I'll meet you there

RUMI

Numbers and Punctuation

Don't Forget about Numbers!

Numbers often don't get much attention, with letters taking center stage most of the time. Yet numbers and punctuation do provide some fun twists to change up the usual fare. While legibility is always paramount, there's still wiggle room for creativity.

The number samples on the following pages work for both printing or cursive. When using numbers with text, choose styles that match or complement one another. It helps to write all ten examples to discover your favorite ones. These styles merely scratch the surface, so if you'd like more practice, try making your own set of numbers.

For further fun, think of someone you can mail a note to, and write their address on an envelope. Addresses are perfect for number practice, and for a bonus, you get to work on combining numbers with print or cursive to create a cohesive look.

1234567890 !?&

1234567890!?&

1234567890 !?&

1234567890!?&

1234567890

eell **TRY IT:** Copy these number and punctuation styles on the blank lines provided.

1 2 3 4 5 6 7 8 9 0 ! ? &

1 2 3 4 5 6 7 8 9 0 ? &

1 2 3 4 5 6 7 8 9 0 ! ?

1 2 3 4 5 6 7 8 9 0 ? &

1 2 3 4 5 6 7 8 9 0

TRY IT: Copy these other number and punctuation styles on the blank lines provided.

The Alluring Ampersand

The ampersand deserves a special shout-out of its own for its beauty, uniqueness, and difficulty. Practicing ampersands is a boot camp experience that makes even complicated letters and punctuation marks seem easy.

The ampersand, with all its modern glory, is actually a very ancient glyph. Early examples of the ampersand have been discovered on papyrus and in graffiti on a wall in Pompeii, dating back to the first century A.D. It is often seen in business names today, such as Barnes & Noble, AT&T, and Ben & Jerry's.

This historical symbol was rejected as the twenty-seventh letter of our alphabet, but it's making a comeback due to texting, social media, logos, and typography trends. The ampersand originates from the Latin word *et*, which means "and." The ancient Roman scribes combined the *e* and *t* to form a ligature (a character created from joined letters) to save time and space.

Try making a few of these variations of the ampersand seen on the following page and enjoy adding them to your handwriting practice.

●◆ fun facts

In the early 1800s, the ampersand was considered part of the alphabet. When schoolchildren recited their ABCs, they would chant "and per se and" after the Z, meaning literally "and, by itself, &." The phrase gradually evolved into the word *ampersand*.

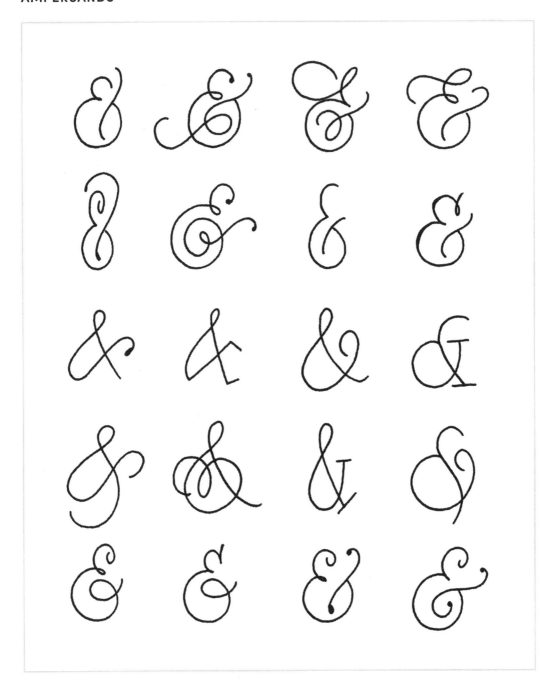

ell **TRY IT:** Copy these ampersand options on a piece of practice paper.

Making Handwriting Work for You

Finding Time to Handwrite

Ideally, set a regular time and place to practice your handwriting. Start with shorter sessions, even ten or fifteen minutes, that work well with your normal routines. Sticking to regular, doable practices will be more productive than trying to cover a lot of ground in occasional marathon sessions. Customize your practice to fit your lifestyle and personality. For example:

- If you love music, write out favorite song lyrics.
- If you're a member of a book club, start a log to record a synopsis of each month's selection or simply copy your favorite excerpts.
- Do you enjoy a good quote? Use your practice time to assemble a handwritten compilation.
- If your passion is sports, fill a notebook with trivia on athletes or teams you follow.
- If you love cooking, you may want to start a handwritten recipe collection.
- When I was expecting my first child, I filled a journal with letters to the baby. You'll have much more incentive to write if the words line up with your interests, knowledge, and experiences.

✏ handwriting heroes

Anne Morrow Lindbergh is well known for her timeless book *Gift from the Sea*. First published in 1955 and the top nonfiction bestseller in the US for over a year, it's still in print today. In her first paragraph, she reveals, "I began these pages for myself, in order to think out my own particular pattern of living, my own individual balance of life, work and human relationships. And since I think best with a pencil in my hand, I started naturally to write…"

Fortunately, there are a lot of ways to intentionally squeeze handwriting into daily life, if a set time and place won't always fit into your schedule. They may not seem like much, but even a few minutes of writing every day will add up. You can also grab a few minutes of handwriting practice during television commercials, in waiting rooms before appointments, and when you arrive early for a production and are waiting for the show to start. When you're on the go, get in the habit of making sure that your handbag or backpack is stocked with writing supplies.

Ideas for What to Handwrite

Read on to see how you can incorporate handwriting into other purposeful endeavors that benefit you and those around you.

Lists

If you're a list maker, get in the habit of writing all your lists by hand. Even if you're the only one who will see them, use your lists to implement the strategies you've learned for legibility and consistency. Writing out lists is also a great time to play with variations of capital letters or new styles of cursive and printing to expand your repertoire. Use lined paper for your lists to help with proportions and spacing.

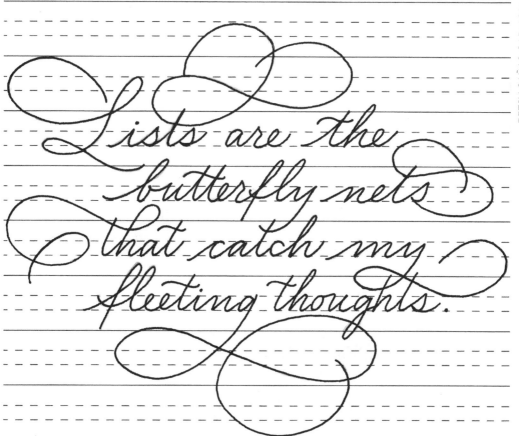

Gratitude Journals

If you like the idea of combining your handwriting practice with a happiness-boosting activity, start a gratitude journal. There are several approaches regarding how much and how often to write. You may want to:

- List a certain number of things you are thankful for every night before going to sleep.
- Write for a designated number of minutes every day.
- Write a longer, more detailed journal entry once a week rather than deciding on a predetermined number of items to record daily.

You can buy journals with writing prompts that offer guidance and fresh ideas if you get in a rut, or simply use a lined or dotted blank book to record your reflections.

handwriting heroes

If you're not sure how to begin a gratitude journal, simply start by recording three things you are grateful for each day. Oprah Winfrey has talked repeatedly about her habit of keeping a gratitude journal. "Before bed," she declared, "it's my gratitude journal.... It's enhanced and lifted my life in a way I can't even describe."

Appreciation is a wonderful thing. It makes what is excellent in others belong to us as well.

VOLTAIRE

Besides providing regular handwriting practice, research conducted by the University of Minnesota and the University of Florida found that people who wrote down the positive aspects of their day before going to sleep reported feeling less stress and anxiety. Psychology professor Robert Emmons, a leading expert on the subject of gratitude, writes extensively on how exercises such as writing in a gratitude journal help you overcome hardships, connect with others, live mindfully in the present, and curb negative emotions like worry and self-doubt.

Bullet Journals

Keep a bullet journal or planner. Bullet journaling was introduced by Ryder Carroll after he had explained his journaling methods to a frazzled friend who was planning her wedding. She was mesmerized by the system he expounded and encouraged him to share his ideas with others. When he first published them in 2013, it didn't take long before the bullet journal became a new obsession. People all across the world are discovering that besides keeping you organized, bullet journaling also provides a fun and trendy outlet for practicing your handwriting.

If you haven't explored bullet journaling before, it's an eclectic system of recording lists, plans, and diary entries all in one place and customizing it for your specific needs and goals. There's lots of information online about how to get started and what features are offered in different brands of bullet journals, although any journal will work fine. When you peruse a few examples, you'll see that it can be as simple or as elaborate as you want.

Because bullet journals include a variety of categories, they are the perfect platform to show off the different lettering styles you've learned here. There are no rules, so whatever your topic, mood, or page layout, you can switch back and forth

handwriting heroes

A prolific journal keeper, it's estimated that Leonardo da Vinci created more than 20,000 pages of notes and drawings, of which over 7,000 pages have survived. For over forty years, he wrote by hand in journals about a shockingly broad array of topics that piqued his curiosity. He didn't try to comply with society's rules—his journals are filled with curious spellings, invented words, and his own version of shorthand. He also didn't care too much about punctuation.

between printing or cursive, slanted or vertical letters, capitals or lowercase. Spend as much or as little time on bullet journaling as you want, but it's typical to spend ten or twenty minutes a day recording entries.

Notes

Write notes by hand during meetings and when listening to podcasts, sermons, or lectures. Take advantage of handwriting possibilities at seminars, classes, orientations, workshops, and training sessions. Not only will you be using valuable time for practice, you will remember things that you write down better than things you just hear. Even if it's not necessary to record the content, you can still log some handwriting practice by taking notes on whatever words or phrases stand out to you.

Letters

Writing letters or sending cards is another great way to practice your handwriting, with a dual purpose of making someone else's day. We all know what a welcome sight it is to find a handwritten letter among the bills, catalogs, and junk mail, and it only takes a few minutes of your time.

*So much has
been given to me
I have not time
to ponder over
that which has
been denied.*

HELEN KELLER

If you're like me and have a hard time writing straight on envelopes, draw lines with a thick marker onto cardstock paper, trim it to size, and place it inside the envelope. Unless the envelope is lined or a dark color, you should be able to see the lines through the paper. Tuck cards or pieces of stationery in your purse or briefcase when you're traveling, so you can write letters on the go when you have time to spare.

Handmade Gifts

One year for our daughter's birthday, my sister surprised her with a personalized, all handwritten cookbook. She wrote out a few dozen kid-friendly recipes and brought the pages to an office supply store where it was spiral-bound and laminated into a keepsake that has been treasured for years.

Other customizable and memorable gift ideas might be compiling pages of handwritten adages for someone who loves words and sayings, writing your memoir in your own penmanship as a gift for your children or grandchildren, or handwriting a collection of words of advice for a graduate or newlywed couple. Use your imagination and come up with your own gift ideas.

> **✑ handwriting heroes**
>
> "I'm an actress, a writer...a pretty good cook, and a firm believer in handwritten notes," Meghan Markle said in an interview before her marriage to Prince Harry. "If the guy is going to write the girl a letter, whether it's chicken scratch or scribble or looks like a doctor's note, if he takes the time to put pen to paper and not typing something, there's something so incredibly romantic and beautiful about that."

Good Old-Fashioned Copy Work

In the seventeenth and eighteenth centuries, copy work was the norm. Kids copied poetry, prose, quotes, and excerpts from great literature. It was a simple method for them to practice penmanship, but in time, other hidden benefits emerged. Putting their pencils to paper and copying correctly written passages was much more than a lesson in handwriting. It introduced students to the mechanics of proper language. They learned spelling, grammar, punctuation, and sentence structure. They absorbed styles of different writers and poets.

This method of learning by imitation was considered a tried-and-true step in the process of learning how to formulate their own writing.

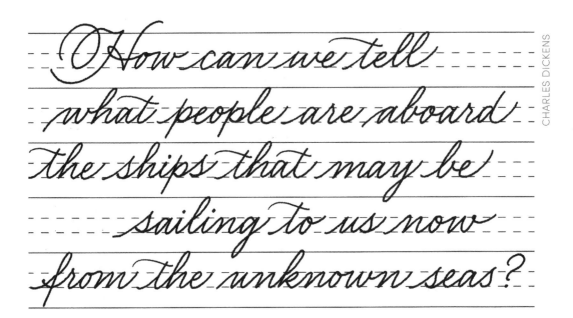

How can we tell what people are aboard the ships that may be sailing to us now from the unknown seas?

Copy work fell out of fashion in the nineteenth century, when educators believed that teaching writing principles and allowing for creative expression was sufficient on its own to develop good writers.

However, the old school of thought regarding copy work has been recirculating. Do you love a good book and wish you could write like some of your favorite authors? Recent articles detail a revived interest in copy work. Why this archaic practice? Because of the incredible results it produces.

Jennifer Manuel, author of *The Heaviness of Things That Float*, encourages writers to open books written by authors they esteem and write out the paragraphs by hand, word for word. She did this every morning for a year and attributes producing her best work to this simple exercise, claiming that imitation, counterintuitively, helped her find her own voice.

Similar to babies learning to talk, athletes honing their sport, and famous artists like Picasso spending years studying the greats,

handwriting heroes

Many famous authors favored copy work. Jack London wrote by hand every word from Rudyard Kipling's works as an in-depth study into the writer he found most inspiring. Robert Louis Stevenson, known for his keen ability to choose just the right word, diligently wrote out passages from his favorite authors, read them carefully, and tried to rewrite them by memory after only a couple readings!

persistent attention to copy work exposes you to the flow, style, and syntax of truly great writing.

Modern writers and educators often coach their students to learn from many authors and genres to assuage the fear of copying another writer's style. If you want your handwriting to improve, along with the added perk of developing your skill as a writer, keep a stack of your favorite books handy, and write out a few passages every day.

Social Media Platforms

Would you like an online record of your progress? It's simple to create a separate social media account, such as an *Instagram* or *Facebook* page, to chronicle your handwriting adventure. Social media is also a great way to build a like-minded community of people all over the world. Commit to posting a few times a week or as regularly as you can.

On January first of 2017, I made a goal to create lettering every day for one year and post it on my *Instagram* account. Although I missed a few days here and there, I learned a lot about quieting my excuses and

I love writing!
I love the
swirl and swing
of words
as they tangle
with human emotions!

—JAMES MICHENER

showing up whether I felt inspired to write something or not. I started carrying a notepad and pencils with me everywhere, practicing a few minutes in my minivan in the parking lot while waiting to pick up kids after sports practices or music lessons, and using other fragments of time that I hadn't considered before. I kept a pen and paper handy for aimlessly writing whatever came to mind during longer phone conversations, and whenever I read anything from a book or article that jumped out at me, I stopped immediately and wrote it down.

These habits rewarded me with improvement, but also with great joy. In spite of the rapid-fire changes in our lives and in society, I was constantly reminded how writing by hand helps us slow down and process the things in our lives that really matter to us.

You will recognize your own path when you come to it because you will suddenly have all the energy and imagination you will ever need.

SARA TEASDALE

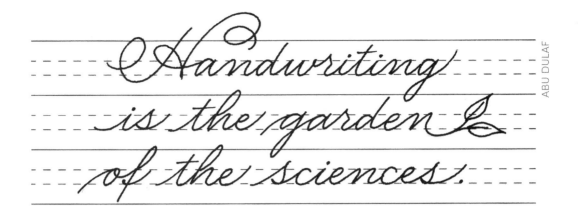

It's heartening that people are joining the ranks of handwriting advocates, lettering artists, and calligraphers by the thousands. If you decide to post your handwriting journey on *Instagram*, use the hashtag #lostartofhandwriting so we can cheer each other on. By sharing your work and following others who inspire you, you'll open yourself up to new friendships, encouragement, ideas, and resources to propel you further along your journey.

Advanced Practice with Calligrams

One of the most rewarding things about handwriting is the ability to think about the meaning of the word and express it creatively through how we write it. When words are written to visually correlate with the meaning of the text, this is called a calligram.

Calligrams can be a single word but also a phrase, poem, or text of any length. They range from very simple to elaborately illustrated. They can incorporate color and texture, but we'll start with simple calligrams, using monoline lettering with a basic pen or pencil.

Creating a word so that it resembles its meaning is a compelling exercise and an ideal way to get out of a rut if you ever feel bored or stuck in your handwriting practice and want to try something new.

To start with, think of a word. Pause for a moment before picking up your pen or pencil. Contemplate what the word means to you, and let other descriptive words come into your mind. Imagine acting out the

word, or think of people who remind you of your word. As much as possible, try to feel the emotion of your word before you write it. Now, let's start the process of putting your word onto paper. Here are a few questions to consider if you don't know where to start:

- Would your calligram be better expressed with uppercase or lowercase letters, or both?
- Does the meaning of your word fit best with slanted or vertical letters?
- Does the definition of your word seem more in line with printed or cursive letters?
- If printed, serif or sans serif?
- Would the meaning of your word be better expressed with simple letters or more ornate ones?
- Do you envision your calligram spread out or more concisely spaced?
- What about the base line? Does your word seem like it would sit formally on the traditional base line or bounce above and below the line to convey something about the meaning of the word?
- If there are any cross bars in your word, do you picture them straight or curvy, high or low?
- Does the definition of your word lend itself to flourishing or any other embellishment or illustration?
- When you think about the meaning of your word, would it be expressed better in tall or short letters, large or small, wide or thin, angular or rounded?

Depending on your word, you may think of other creative questions to ponder and ideas to doodle. There may be a letter in your word that lends itself well to expressing the meaning, such as the *S* in the word *serpentine*, or the *O* in the word *global*.

For an example, I'll walk you through my thought process on a calligram I created. One of my favorite letters is *A*. I also love flourishing, so I wanted a word with a meaning that was conducive to flourishing. I decided on the word *Artistic*. The word *artistic* has different connotations for different people, but I concentrated only on the meaning through my lens of experiences.

Artistic. To me, it is an elegant word, yet generous, kind, and approachable. I envisioned it in script, but in a steady hand, rather than bouncing on the line. I wanted to express freedom and movement and joy, but in an orderly, balanced way. I used traditional letter forms, but added some unconventional twists on the cross bars of the *A* and *t*'s. I hoped to portray, through the flourishes surrounding the word, the connectedness and influence of community.

Another important point: it took a few attempts before the design caught up to my vision for how I wanted it to look. Some ideas were abandoned. At first, I didn't have any flourishes below the word, as there are no letters with descenders. But I wanted to balance the flourishes on the top, so I added some free-floating flourishes on the bottom.

To hopefully spark ideas for you, I made a page of simple calligrams using a variety of words (see the following page). Again, it's subjective how we each choose to express the meaning of words. For example, I chose to create the word *Reality* a bit humorously, with different angles, heights, and letter sizes. I wanted the word itself to express strength but not sugarcoat the imperfections that exist in ordinary life.

The words *Energetic* and *Speedy* are both sloping upward to show confidence, progress, and the optimism I associate with these two words. *Kindness* and *Joyful* both involve several flourishes. When I was drafting the designs, I thought of kind people looking for ways to reach out to someone as they go about their ordinary tasks, and joyful people,

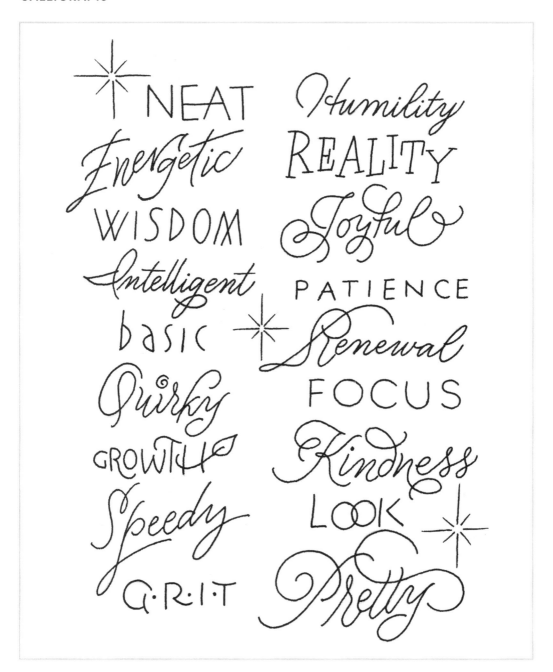

NEAT
Energetic
WISDOM
Intelligent
basic
Quirky
GROWTH
Speedy
G·R·I·T

Humility
REALITY
Joyful
PATIENCE
Renewal
FOCUS
Kindness
LOOK
Pretty

TRY IT: Copy the styles here and/or create your own. You might concoct a completely different way to write the same word, based on your own interpretation of the meaning.

with the contagious quality of finding amusement in everything, and laughing often.

My rendition of the word *Grit* might not be as tough-looking as the meaning suggests. I used all caps to show strength and determination, but curved lines to demonstrate the flexibility that has been necessary for me to reach goals I set for myself. The dots between the letters represent the sandpaper-like particles that smooth and teach us as we persevere.

Calligraphy

If you've enjoyed perfecting your handwriting, exploring the world of calligraphy is a natural addition to the foundation you've already built. The difference between handwriting and calligraphy comes down to the tools and the rules.

Calligraphy is a broad field of study, but the two basic camps are:

1. **Broad-edged calligraphy** uses a nib with a flat edge, such as Brause, Mitchell, or Speedball, and is required for styles such as Italic, Foundational, Blackletter, and Uncial. The nib is typically dipped in either ink or gouache, and rules involve the precise angle of the nib, height of the letters, stroke sequence, and letter shapes.
2. The **pointed pen** is used for script styles such as Copperplate and Spencerian. This lettering requires using pressure on the downstrokes and releasing pressure to make thin hairlines for the upstrokes. These elegant, classic styles use an oblique or straight pen holder and a nib with a pointed tip, such as the workhorse Nikko G or the flexible Gillott 303. As in broad-edged calligraphy, the nib is dipped in ink or gouache that is prepared to the right consistency.

Modern brush lettering requires a flexible brush-tip marker, paintbrush, or water brush, and is derived from traditional script and printed letter forms. In both classic and modern calligraphy, you'll find that styles of lettering artists can differ widely. Some of the current trends

involve bouncing on the base line; mixing different styles; adding banners, flourishes, and other embellishments to create balanced layouts; and blending colors with special markers such as the Tombow series or Ecoline liquid watercolors. Chalk is also a popular medium for modern lettering layouts, and there's an assortment of chalk and chalk markers available to create your designs.

This alphabet, along with the following quote by Albert Einstein, is a sample of some basic modern brush lettering using a Tombow Fudenosuke hard-tip marker. Brush lettering looks very similar to monoline handwriting, but the added texture of thick and thin strokes necessitates a little more time and attention to each stroke.

▶ Brush-lettered lowercase letters.

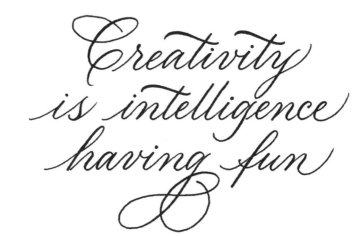

▶ In this example, you can see a simple layout of centering each line and adding a flourish off a descender on the bottom line.

Joining a calligraphy guild in your area will expose you to the best teachers available in all of these styles mentioned and more. You can also learn from books, take classes online, and watch tutorials.

How to Find Your Own Style

If you want to explore more terrain in the realm of hand lettering, you may be wondering how to unearth your own unique style. A great way to start is by emulating handwriting styles and variations that inspire you, in order to build your confidence in the world of letters. After that important step, you'll find that the more you take your practice beyond imitation, the more your own passions and preferences will emerge. When you give yourself creative license to sit with your writing tools and simply have fun with letters, your personality will find a stage on which to perform. It doesn't always come easily or naturally, and for sure not overnight, but with persistent trial and error, your voice will come through in your writing.

You can also take lettering classes that are not your go-to styles, just to stretch yourself to learn new things. I've found that a skilled teacher who is passionate about the course material will open another world for me with their contagious excitement and expertise. All you learn will help build upon and improve what you already know. And the best part is that there is always more to learn.

At the point of the pen is the focus of the mind

JAMES LENDALL BASFORD

Fill your paper with the breathings of your heart

WILLIAM WORDSWORTH

Conclusion

In an age of practicality and technology, this book is a meandering answer to the question, "Why handwriting? What can it give me?"

As an active person who prefers the outdoors and struggles to sit still, I've often puzzled over what it is about handwriting, a sedentary activity, that draws me in and holds me captive. What does it offer? Ironically, I've found that it's not what handwriting gives us, but what we bring to handwriting, that evokes the greater blessing. My epiphany came unexpectedly with the juxtaposition of these two quotes:

> "At the point of the pen is the focus of the mind."
> —James Lendall Basford

> "Fill your paper with the breathings of your heart."
> —William Wordsworth

Mind and heart! In writing we offer both intellect and emotion. Many creative pursuits engage both mind and heart, but handwriting is unique in its powerful capacity to convey not just words, but the meaning, beauty, and personal undertones they represent.

My hope is that you've also been dazzled by the wonder and depth of penmanship, and that together we'll be perpetual students: reveling in the joy of learning, imparting a reflection of mind and heart through the marks we put on paper, and spreading the word to others.

Further Reading

"The Analog Method for the Digital Age." *Bullet Journal*, https://bulletjournal.com/.

Bibel, Sara. "Poof! 5 Little-Known Facts about How J.K. Rowling Brought Harry Potter to Life." *Biography.com*, 31 July 2014, www.biography.com/news/jk-rowling-harry-potter-facts.

Bounds, Gwendolyn. "How Handwriting Trains the Brain." *The Wall Street Journal*, 5 Oct. 2010, www.wsj.com/articles/SB100014 24052748704631504575531932754922518.

"Correct Pencil Grasp for Handwriting." *OT Mom Learning Activities,* www.ot-mom-learning-activities.com/correct-pencil-grasp.html.

"Cover Letter: National Card and Letter Writing Month." *USPS Sustainability—"Skip the Trip" Savings Calculator*, about.usps .com/postal-bulletin/2001/html/pb22046/cover.html.

"Daily Deliveries Down to One—1950." *National Postal Museum,* https://postal museumblog.si.edu/2016/04/daily-deliveries-down-to-one-1950.html.

Diagram Group. *Lettering & Calligraphy Workbook*. Sterling, 2006.

Dickinson, Emily, et al. *The Gorgeous Nothings*. Christine Burgin/New Directions, in Association with Granary Books, 2013.

Edwards, Betty. *The New Drawing on the Right Side of the Brain: A Course in Enhancing Creativity and Artistic Confidence*. Souvenir Press, 2000.

Eschner, Kat. "Why JFK Kept a Coconut Shell in the Oval Office." *Smithsonian.com*, 2 Aug. 2017, www.smithsonianmag.com/smart-news/why-jfk-kept-coconut-shell-white-house-desk-180964263/.

"5 Brain-Based Reasons to Teach Handwriting in School." *Psychology Today*, 15 Sept. 2016, www.psychologytoday.com/us/blog/raising-readers-writers-and-spellers/201609/5-brain-based-reasons-teach-handwriting-in-school.

Founders Online. "Advice to a Young Tradesman [21 July 1748]." National Archives and Records Administration, https://founders .archives.gov/documents/Franklin/01-03-02-0130#BNFN-01-03-02-0130-fn-0005.

"Graphite Grading Scales Explained." *Pencils.com*, 9 Nov. 2016, https://pencils .com/hb-graphite-grading-scale/.

Hamilton, Charles. *In Search of Shakespeare: A Reconnaissance Into the Poet's Life and Handwriting*. Harcourt Brace Jovanovich, 1985.

Hansan, Mary Anne. "Writing Longhand on Paper Is the Key to These Fiction Writers' Success." *Paper and Packaging Board*, 27 Sept. 2016, www.paperandpackaging.org/pulp-magic/writing-longhand-on-paper-is-the-key-to-these-fiction-writers-success.

Hdez, Gabriela. "Interesting Facts about Leonardo da Vinci's Journals." *Owlcation*, 1 Oct. 2016, https://owlcation.com/humanities/Interesting-Facts-about-Leonardo-Da-Vincis-Journals.

Johnny. "The Deep Sea Mystery Circle—A Love Story." *Spoon & Tamago*, 12 Sept. 2017, www.spoon-tamago.com/2012/09/18/deep-sea-mystery-circle-love-story/.

Klass, Perri. "Why Handwriting Is Still Essential in the Keyboard Age." *The New York Times*, 20 June 2016, well.blogs.nytimes.com/2016/06/20/why-handwriting-is-still-essential-in-the-keyboard-age/.

Konnikova, Maria. "What's Lost As Handwriting Fades." *The New York Times*, 2 June 2014, www.nytimes.com/2014/06/03/science/whats-lost-as-handwriting-fades.html.

Lindbergh, Anne Morrow, and Reeve Lindbergh. *Against Wind and Tide: Letters and Journals, 1947–1986*. Pantheon Books, 2015.

Lindbergh, Anne Morrow. *Gift from the Sea*. Chatto & Windus, 1955.

Lindbergh, Anne Morrow. *Locked Rooms and Open Doors: Diaries and Letters of Anne Morrow Lindbergh, 1933–1935*. Harcourt Brace, 1993.

Manuel, Jen. "How to Write Your Best Story Ever with One Epic Exercise." *Jennifer Manuel*, 22 Apr. 2017, www.jenmanuel.com/process-tips/write-best-story-ever-one-epic-exercise/.

Marsh, Jason. "Tips for Keeping a Gratitude Journal." *Greater Good*, https://greatergood.berkeley.edu/article/item/tips_for_keeping_a_gratitude_journal.

May, Cindi. "A Learning Secret: Don't Take Notes with a Laptop." *Scientific American*, 3 June 2014, www.scientificamerican.com/article/a-learning-secret-don-t-take-notes-with-a-laptop/.

McCarthy, Cheryl Stritzel. "Is the Writing on the Wall for Handwriting?" *Chicago Tribune*, 14 Dec. 2010, www.chicagotribune.com/living/ct-xpm-2010-12-14-sc-fam-1214-education-handwriting-20101214-story.html.

McKay, Brett, and Kate McKay. "Want to Become a Better Writer?: Copy the Work of Others!" *The Art of Manliness*, 28 May 2018, www.artofmanliness.com/articles/want-to-become-a-better-writer-copy-the-work-of-others/.

"Members." *Writing Instrument Manufacturers Association | Handwriting*, www.pencilsandpens.org/members.php.

Milsom, Lauren. *Your Left-Handed Child: Making Things Easy for Left-Handers in a Right-Handed World*. Hamlyn, 2014.

Morton, Ella. "Library Hand, the Fastidiously Neat Penmanship Style Made for Card Catalogs." *Atlas Obscura*, 17 Feb. 2017, www.atlasobscura.com/articles/library-hand-penmanship-handwriting.

Mueller, Pam, and Daniel Oppenheimer. "The Pen Is Mightier Than the Keyboard." *Psychological Science*, 23 April 2014, http://journals.sagepub.com/doi/abs/10.1177/0956797614524581.

Patterson, Susan. "Scientific Proof That Being Grateful Is Good for You." *Tropical Health*, 13 Dec. 2017, www.tropicalhealth.com/scientific-proof-grateful-good/.

Pinola, Melanie. "Why You Learn More Effectively by Writing Than by Typing." *Lifehacker*, 22 Feb. 2016, https://lifehacker.com/5738093/why-you-learn-more-effectively-by-writing-than-typing.

Poswolsky, Adam Smiley. *The Quarter-Life Breakthrough: Invent Your Own Path, Find Meaningful Work, and Build a Life That Matters*. TarcherPerigee, 2016.

"Right to Left Languages." *Andiamo!*, www.andiamo.co.uk/resources/right-left-languages.

"r/Tabled—IAmA: Hello Reddit, George Clooney Here." *Reddit*, www.reddit.com/r/tabled/comments/1wed8i/table_iama_hello_reddit_george_clooney_here_amaa/.

Seifer, Marc J. *The Definitive Book of Handwriting Analysis: The Complete Guide to Interpreting Personalities, Detecting Forgeries, and Revealing Brain Activity Through the Science of Graphology*. New Page Books, 2009.

Shepherd, Margaret. *The Art of the Handwritten Note: A Guide to Reclaiming Civilized Communication*. MJF Books, 2010.

"Teresa R. Funke." *Teresa Funke & Company*, www.teresafunke.com.

Walker's Chapters. "Why Leonardo da Vinci Wrote Backwards." *Medium*, 25 Sept. 2016, https://medium.com/@walkerschapters/why-leonardo-da-vinci-wrote-backwards-76187255d4ba.

"What Is the Origin of the Ampersand (&)?" *Oxford Dictionaries | English*, en.oxforddictionaries.com/explore/origin-of-ampersand/.

"Which Letters in the Alphabet Are Used Most Often?" *Oxford Dictionaries | English*, en.oxforddictionaries.com/explore/which-letters-are-used-most/.

"Why Is Handwriting Still Important in the Digital Age? *Pen Heaven*, www.penheaven.co.uk/blog/handwriting-still-important-digital-age/.

Wild Thyme Creative, www.wildthymecreative.com.

Wilt, Abigail. "Just Like a Southerner, Meghan Markle Appreciates a Handwritten Note." *Southern Living*, www.southernliving.com/culture/celebrities/meghan-markle-handwriting.

Winters, Eleanor. *Mastering Copperplate Calligraphy: A Step-by-Step Manual*. Dover Publications, 2014.

Index

189